D0575479

EYE OF THE WEST

EYE OF THE WEST

PHOTOGRAPHS BY NANCY WOOD

UNIVERSITY OF NEW MEXICO PRESS
Albuquerque

© 2007 by Nancy Wood
All rights reserved. Published 2007
Printed and bound in China by
Everbest Printing Company Ltd. through
Four Colour Imports, Ltd.

13 12 11 10 09 08 07 1 2 3 4 5 6 7

Library of Congress Cataloging-in-Publication Data

Wood, Nancy C.
Eye of the West : photographs by Nancy Wood / Nancy Wood.
p. cm.
ISBN 978-0-8263-4319-2 (cloth : alk. paper)
1. West (U.S.)—Social life and customs—Pictorial works. 2. Colorado—Social life and customs—Pictorial works. 3. New Mexico—Social life and customs—Pictorial works. 4. West (U.S.)—Biography—Pictorial works. 5. Colorado—Biography—Pictorial works. 6. New Mexico—Biography—Pictorial works. 7. Pioneers—Colorado—Pictorial works. 8. Pie Town (N.M.)—Pictorial works. 9. Ute Indians—Colorado—Pictorial works. 10. Taos Pueblo (N.M.)—Pictorial works. I. Title.

F590.7.W66 2007
978—dc22

2007008927

Book composition by Damien Shay
Body type is Minion 12/18
Display type is Albertus and Univers

TO THE MEMORY OF
ROY STRYKER

CONTENTS

ACKNOWLEDGMENTS

This book had its beginnings more than thirty years ago when I, armed with little more than a camera and a vision of what I wanted the Grass Roots People to be, set out into the vastness of Colorado in my battered Subaru. I am indebted to the hundreds of people I met along the way who shared with me their lives and stories and hospitality. When I discovered the Utes, they gave me an entirely new perspective that helped me grow as a photographer and as a person. My thinking about Indians changed. I clicked away, recording this little-known tribe.

The Taos Indians opened yet another dimension. No longer did I look at life the same way after the four years I spent photographing the pueblo. I saw these Indians in all their kindness and humanity, immersed in a past that gave them tolerance and dignity, not as tourist attractions or curiosities. They gave me cautious access to their lives. The pictures I took there are perhaps my best. I thank the Taos people for making the backbone of this book possible.

When I first approached Luther Wilson, gifted director of the University of New Mexico Press, about doing *Eye of the West*, he agreed almost immediately. He told me what he wanted, and I did it.

The first job was editing more than a thousand images with my long-time friend and editor, Foxhole Parker. It took days, but he was patient, as he has been for twenty-two years and fifteen books. He sequenced most of the book.

David Willsey was in charge of tech support, a good thing because I would have bashed the computer to death otherwise. He remained calm, putting up with my ignorance with a good-natured smile.

The enormous task of photo printing first fell to Ford Robbins who printed several thousand images with meticulous care. From there Gabe Holton at Visions did a masterful job with my negatives, assisted by Nikkol and Cody Brothers.

At the University of New Mexico Press I am grateful to my assistant editor, Kristen Adler, book designer Damien Shay, and copyeditor Valerie Larkin.

All of you made this book what it turned out to be.

NANCY WOOD
Santa Fe, New Mexico
January 2007

ix

INTRODUCTION

The Early Years, 1946–1954

There is nothing in my past to suggest I would ever become a writer or a photographer. It's a miracle, in fact. But early on, I was interested in people's lives, what they wore, the way they chewed gum. Did they have dirty fingernails? A kindly disposition? I used to look in the window of a seedy downtown bar when my mother and I went shopping in Trenton, New Jersey, where we lived. I would press my face to the window and look in. Men wore snap-brim hats, tweed coats with patched elbows, and women wore their hair in an upsweep like Betty Grable, my favorite movie star. Mama called them floozies. They wore red lipstick, platform heels, and penciled eyebrows. In the bar there was a haze of cigarette smoke. I noticed how it rose to the ceiling. The smell of stale beer was thick and terrible, but I liked it. I hung around to see if some drunk would fall off the barstool. I wanted to see what the floozies did next.

"Nancy, you bad girl, get away from there," my proper Irish mother would say, dragging me away. The bar was forbidden, and that's why I liked it. I was ten and just beginning to learn about the world. Pictures were etched in my mind of the priest saying Mass in his fancy clothes. My baby brother chewing on his silver rattle. My grandmother hiding her gin bottle behind the sofa. Mama taking out her upper plate and sticking it in a glass of water. The boy in my school with a wart on his nose. The world was filled with mysterious things. I studied the nuns dressed up like penguins. The milkman with his glass bottles arranged in a wire rack. I noticed my German father's chipped tooth, the part in his hair. All this got stored away until the day, many years in the future, when I would ask myself what made a good picture.

Still a Kid

The war was over. The country was getting back on its feet. We could buy meat and sugar and coffee again. My father's office supply business started to thrive. We moved to a nicer house and bought a maroon Hudson with white leather seats. My mother said we were trying to keep up with the Joneses, whatever that meant. In my sunny third-floor room I cut pictures out of the *National Geographic* and covered my walls with images of Borneo, the Belgian Congo, and

Madagascar. The name aroused my curiosity. I knew it was dangerous there. My mother frowned on danger. She was afraid something would happen to me, the only girl in a family of three boys. I had to hold her hand when crossing the street until I was twelve years old. Kids laughed at me, a skinny girl who couldn't even go to the movies alone. Madagascar, I wept into my pillow.

The Beginning of Awareness

"Nancy," Mama said one day, before I was even on the rag, "you better start thinking about your future." She had my life all picked out for me. I could become a teacher, a secretary, or a housewife. That's all I could be. That's what she and her mother and grandmother had been. The nuns said I should join a convent and prepare for eternity in heaven. I didn't want to do any of those things. One day I borrowed my mother's box Brownie and took pictures of the dog, the porch furniture, and my mother hanging up clothes. I took a shot of the old man next door out walking his dog. Fuzzy, ghostlike images resulted, but I had begun to see a certain kind of life. I aimed the camera out the window at a squirrel. Again it came out fuzzy. I took a picture of my grandfather asleep in his chair. He had a halo around his head. "Look," I said, "Grandpa's going to be with the angels." And sure enough, he died less than a week later.

As I said, I could see things.

The Inner Journey Begins

There was a way to keep from going crazy in my family: a way to escape my father's rages, my mother's helplessness, my father's assaults with a belt. I invented my own world. I wrote in my diary about the

frozen Delaware beneath our house where velvet reindeer pranced; the goose with golden feathers who carried me on his back; the prince who came in the night with roses. As I got older, I went to tea dances at Lawrenceville, wearing white elbow-length gloves, a felt hat with a veil, and an ankle-length taffeta dress that made me look like a frump. Boys didn't want to dance with me. I was as thin as a stick with frizzy red hair. I sat mournfully on the sidelines staring at the gymna-

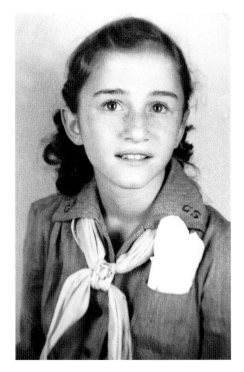

Nancy Wood in her Girl Scout uniform, 1948

sium walls. Boys were dumb. School was dumb. My parents were dumb. I read my books. *Jane Eyre. David Copperfield. Little Women. Huckleberry Finn. The Encyclopedia Britannica.* With books, I could escape. Books didn't care how ugly I was in my thick glasses and puke-green school uniform with droopy socks. Books made me feel like a person. All I wanted to do was read and hide out from the world.

As my father became more affluent, we bought a shore house. We went there every summer. It was where I learned to sail, but I never got it quite right. I didn't lie on the beach like other girls. It was a waste of time. One day I rode my bicycle to the local weekly newspaper and applied for a job. I was fourteen, but I told them I was old

enough to work. They offered me ten dollars a week. At first I wrote about sports, then obituaries, then a society column. With the editor's Kodak I took pictures of traffic accidents, the mayor cutting a ribbon at the new school, lifeguards with their muscular chests. One time I tried to get a picture of Albert Einstein as he was crossing the street, but I was so nervous I dropped the camera and it broke.

On Thursdays I went with the editor to a printshop in Philadelphia, where the paper was printed. They spoke nothing but German. It was very hot in there with the presses going, 110 degrees at least. Air conditioning was not in wide use at the time. The only place to cool off was at the burlesque theater a block away. The editor and I would sit there for hours watching the girls strip to their pasties, strutting and gyrating and throwing articles of clothing to the men in the audience. Meanwhile a man in a green visor ground out tunes on the player piano. I learned some things from those strippers, though I never got to practice them until years later. But I noticed how the men drooled, how the strippers moved like mechanical dolls, how my editor ate popcorn and clapped, glassy-eyed at the sight of those floozies. The burlesque was as forbidden as the bar I used to go to, which is why I never told my mother a thing. She never saw me practicing my burlesque routine in front of the mirror, either. She'd have flipped.

In my senior year, I was editor of the school paper. I had the lead in the school play. A children's magazine bought a couple of my stories. They paid one cent a word, my first income for my writing. The local paper published a syrupy poem about the stars in the sky. There was a thrill in seeing my words in print. After high school, I wanted to go to Wellesley and learn the finer points of the English language. I'd be a writer and live in Greenwich Village and become famous.

"Well, if you want to, go ahead," my mother said. "But you ought to learn to do something useful too. You could be a teacher or a secretary, Nancy."

"Well, I won't," I said.

My father jumped out of his chair and threw his newspaper on the floor. "Why should I educate you?" he raged. "You'll just get married and waste it all."

"But I want to go to Wellesley," I wailed. "I have a scholarship. All you have to do is pay for room and board."

"No," he said firmly. "You can go to Trenton State Teachers College and live at home. That's final." He picked up his paper and rattled it to show he meant it. My mother shook her head. My dreams oozed out of me like blood. I saw myself becoming just like her, making pot roast and lemon meringue pie, setting the table with Melmac. I wanted to die, but I didn't die. I did something far worse.

How to Sell Out before You Even Begin

Barely eighteen, filled with a fateful resignation, I married a college boy I had dated at Lawrenceville. I did it to spite my father, but he didn't care. Off we went to set up house in a university town. My husband was neither good nor bad, neither exciting nor dull; he was an Elvis Presley imitator who gyrated with considerable skill, mouthing the songs that played on the record player, which he accompanied on his cheap guitar. He drank beer with his buddies and stayed out all night and sometimes he smacked me. I had a daughter right away and a son after that. Twenty-one years old and I was up to my ears in diapers. I learned to cook and sew and do laundry. I wrote magazine articles on how to choose the right pediatrician, what to do when

Nancy Wood with printer of her magazine, 1961

your baby has colic, how to get your baby to like spinach. My father had bought me an Underwood typewriter for graduation. I tried my hand at short stories. Too much like Hemingway. I wrote a play about a housewife trapped in a dungeon. I tore it up. I took English courses at the university, checked books out of the library, and stayed up late reading. Sylvia Plath. Dylan Thomas. Robert Frost. Jack Kerouac. I rode the train to Harrisburg and back. I looked at the river flowing past and the green fields dotted with dairy cows. I imagined myself living with a dairy farmer and learning to make cheese.

One day when I was getting ready to gas myself in the kitchen the way Sylvia Plath had done, Elvis received his ROTC assignment: Ft. Carson, Colorado. I looked up Colorado in the encyclopedia. It was filled with mountains and rivers, bandits and Indians and cowboys. Off we went in our battered Plymouth station wagon, the kids in the back, hauling a trailer filled with all our belongings. Two thousand miles. Every mile put me farther from my family and his.

It was 1958, the Eisenhower years. No social consciousness, no women taking risks, no girls peeking in bar windows or going to the burlesque show. In the distance I saw the Rockies pushing toward the sky, a great long wall of jagged rock, impossibly high. The sky was so blue it hurt my eyes. There was Pikes Peak at fourteen thousand feet, with patches of snow in July. I got out of the car and looked at it. White clouds billowed up like giant cotton balls; the air was clear and pure. Before the car was even unpacked the mountains had captured my soul. I knew this was where I belonged and where I would do my work, whatever it was. Later, I drove into the mountains and found a stream and a stand of aspen. I stretched out in the grass and buried my face in the soft earth. I looked at the tiny pink flowers, no bigger than the head of a pin, and I heard birds singing distinctive songs in the trees. I sat up to listen. I wrote on the back of an old envelope:

The mountains take your sadness
and throw it away. The mountains put strength
inside the weakest souls.
Let go of what is holding you back.
The mountains will fill up the space.

It was as if a door had opened. I was going to be somebody. I knew it.

The Photographer

Elvis and I weren't exactly suited. I'd known that all along. His fits of anger were just too much; he banged me around when he was in the mood. I had the bruises to prove it. I showed my mother what he'd done.

"Marriage is forever," she said. "It's the law of the Church. Women are meant to suffer."

"Well, I won't," I said.

So one day, while he was at the army base, I took the children and left. I rented a house in the mountains. The roof leaked, the wind blew in the cracks, mice made nests in the couch. I cried myself to sleep, drank Ripple wine, and smoked Viceroy cigarettes because my mother smoked them. I worked for a classical music station selling advertising in my picture hat, white gloves, and high-heel shoes. I strutted down the street like the strippers of my burlesque days. Men noticed me, but I was tired of selling advertising. One day I thought, why not create a fine arts magazine? I'd have book and movie reviews, articles on theater and music events, and the FM schedule. I needed a photographer.

Fifty dollars a month, I said to the handsome, intense man who sat across from me in the coffee shop. He was a World War II veteran who had been wounded at Normandy. He had attended the Yale Music School and he was playing at local supper clubs to keep himself afloat while doing his photography during the day. He had a lot of teeth. The strongest expletives he ever used were "shoot" and "dag nab it." He had been a hard-shell Baptist, but he wasn't hard-shell anymore; he wasn't anything. War had cured him of rigidity.

The photographer took the job. It wasn't long before we became romantically involved. He taught me about music, literature, art, photography, and history. He had me reading Conrad, Dostoevsky, Hardy, Eliot, Maugham, and Faulkner. He was one of the great American photographers of the late twentieth century, only no one knew it. In 1999 he died virtually unknown outside his small circle of supporters in Colorado.

Now exposed to photography on a daily basis, I borrowed his Leica and took pictures, most of them not very good. He said I had to print my own work in the darkroom, but the fumes made me break out in hives, so I quit the darkroom experience. What was a photograph, anyway?

It's the mirror of the soul, he told me rather grandly. You try to capture the universal truth. Will it stand up one hundred years from now, or is it a fad photograph? He gave me some books to read: Paul Strand, Imogene Cunningham, Cartier-Bresson, Ansel Adams, Edward Weston, Elliott Erwitt. I studied their work until I could tell at a glance what made each one different. Adams was too formal. Cartier-Bresson had a sense of humor. W. Eugene Smith was a humanist. That's the way I'd take pictures, if I ever could. I wanted to be part of the art world and the photographer would help me. But my efforts were mediocre. I soon gave up.

"I'm the photographer," he said. "You're the writer. You're supposed to support me."

I knew I never would be half as good. I picked up a book by Dorothea Lange and looked at the pictures. Now *there* was a genius. She took pictures the way I would if I knew how. The things I saw as

a kid bubbled to the surface. What was there about the scruffy old men in the bar that time? My grandfather with a halo?

"You have enough to do," the photographer said.

But something drew me toward his camera. I didn't know what.

What Marriage Did

We married on March 1, 1961. I was not quite twenty-five years old. We went to Taos on our honeymoon, the first time I had been outside Colorado since I arrived there three years earlier. I remember driving south from Ft. Garland in the late afternoon. Patches of snow dotted the landscape; the trees were bare of leaves. Had there ever been such light, a pale green-gold, clear as glass? Light transforms the most ordinary object, he said. Look at that barn. And he'd stop to take a picture, virtually hopping across the ground. I'd sit in the car and watch him work. The angles he'd use. How he'd wait until the light was exactly right. He drove with one leg over the steering wheel, the camera in his lap. Sometimes he told me to steer while he looked for subjects to photograph. Sometimes I shifted gears. He was happiest when he was rolling down the road, searching out what Cartier-Bresson called "the decisive moment." His pictures were luminous, exquisite. They should have been in the Museum of Modern Art, but they weren't.

I saw Taos Pueblo for the first time the following day. I was not expecting anything so dramatic. It had an otherworldly quality, rich and mysterious. Three- and four-story villages were on either side of the river, much as they had been a thousand years before. I gasped as I got out of the car and looked around. Blanket-wrapped men stood on the rooftop, calling the day's news to one another. Horse-drawn wagons lined the plaza. Some contained wood cut from the forest

above Taos Mountain; others sacks of wheat and flour from the general store. Women in shawls drew water from the stream in buckets and carried it to their homes. Bluish smoke curled up from the chimneys. I heard the beat of a drum from somewhere deep inside the pueblo. Then another. It was primeval, utterly peaceful. A magic erupted and ran across the plaza like a tide. I felt the presence of ancestors from long ago, saw them standing on rooftops and climbing their ladders,

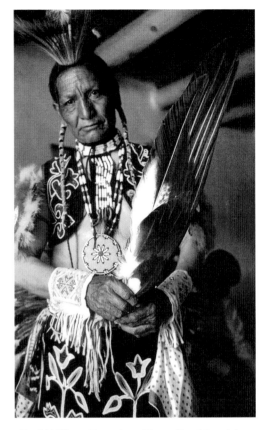

Red Willow Dancing, Taos Pueblo elder, photograph by Myron Wood, 1965. © Pikes Peak Library District.

blankets draped across their shoulders. I belong here, I said to myself.

We had a letter of introduction to Red Willow Dancing, an important pueblo elder. We climbed the ladders to the top floor of the pueblo, where he lived. He was waiting for us, standing perfectly still, wrapped in a plaid cotton JC Penney blanket. He had strong, classic features, long braids intertwined with strips of red felt. His eyes were penetrating. He invited us in. His wife, wearing a home-made cotton dress and moccasins, served us coffee and cookies; she

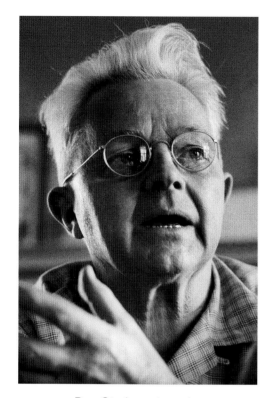

Roy Stryker, photo by
Angus MacDougall, 1970

said nothing. We talked for about an hour, he in short English sentences. I could scarcely take my eyes off his strong, sinewy hands, his great beak nose, the erect way he sat in his chair, his air of utter authority. I wanted to celebrate the magic of this place. But how? Ten years were to pass before I would write a single word. I needed all that time to absorb their ways.

As I left Taos Pueblo that day, Red Willow Dancing gripped my hand and looked into my eyes. He said he hoped I'd come again. He let my husband take his picture in his dance regalia, an eagle feather wand in his hand. As I climbed down the ladder, I looked back. Red Willow Dancing stood on his rooftop, his face turned toward the sun. It could have been 1620. A wave of emotion swept over me. I found myself dancing across the plaza, the dirt blowing up in my face.

Expanding, 1962–1974

The third child was born in 1962, a dark-haired girl named Kate. For several years I wrote nothing except grocery lists. Then a friend of mine gave me his job as southwestern travel stringer for the *New York Times*. I never went anywhere. I couldn't afford to and the *Times* never gave me a travel allowance. I looked up Tombstone in the library, then Yellowstone, Santa Fe, El Paso, and Taos. It sounded convincing enough, along with some stock photographs. The *Times* liked it. A little more money rolled in. I never had to go anywhere. Mesa Verde. Cripple Creek. Steamboat. The Navajo Nation. I went to them through the magic of the library. I listed motels, restaurants, things to see. Deception flourished. But there was money to pay the rent. Another child came along with the unusual name of India.

About this time I plunged into my first children's book, *Little Wrangler*, which the photographer illustrated. It was a warm and human account of a six-year-old boy trying to become a cowboy. Simon and Schuster snapped it up. I was hungry for more. But I needed household help if I was to write full-time. I couldn't afford it, so I signed up for a program at the state hospital. Fifteen dollars per week, plus room and board, and I got a personal lunatic to look after my children. It lasted about a year. "How could you?" my mother said. "*A crazy person?*"

One September we went to New York to visit John Szarkowski, director of photography at MoMA. He invited us to a private reception for the legendary Roy Stryker and his Farm Security Administration (FSA) photographers that evening. Roy Stryker! It was like meeting God! The show was called *The Bitter Years: 1935–1941* and it was organized by Edward Steichen. Roy Stryker, with his shock of snow-white hair, stood in the midst of about eighty huge prints from the FSA—migrants and sharecroppers, the destitute and the desperate. I couldn't take my eyes off the photographs. Powerful,

shocking, and embedded in the reality of the '30s. Nor could I turn my eyes away from Stryker, shorter than I had expected but with a fiery intensity. The place was jammed elbow to elbow. People flocked around the great photographers—Dorothea Lange, Arthur Rothstein, Russell Lee, John Vachon, Gordon Parks, Marion Post Wolcott, Jack Delano, Ben Shahn, Walker Evans. From 1935 to 1943 they documented the plight of America and became world famous in the process. While I was gawking, Stryker started talking to me. He didn't like the show, he said, because it depicted the downside of the Depression. He knew there was a happier side and he wanted to do a book about it. He said he was moving back to Montrose, Colorado, where he was born. I want you to help me do my book, he shouted in my ear. He scribbled his address on a piece of paper. I said I'd be in touch. And then the crowd swept him away.

My association with Stryker lasted ten years. I made several trips to Montrose, about six hours away from Colorado Springs, and then to Grand Junction, where he moved after his wife died, in order to be close to his daughter, Phyllis. Stryker and Red Willow Dancing were the great teachers of my life—one spiritual, one artistic. The Grand Junction trips were trying. I had written an exposé for a national magazine about the radioactive tailings that most of the town was built upon. Studies showed a high incidence of cancer. Real estate prices plummeted. Unemployment rose. The local newspaper ran two front-page editorials saying that if I ever showed up in town they'd tar and feather me.

I *had* to show up. Stryker was in the early stages of Alzheimer's. He wouldn't last long. I felt a deep commitment to helping him do his book. It was insane, really. No money once again, a famous deteriorat-

ing man, a town that wanted to do me in. No matter. I rented a car in Colorado Springs so they couldn't trace me through my license plates, bought a long brown wig, dark glasses, and drove to Grand Junction. I registered at a sleazy motel as Mary Jones of Pueblo, Colorado. I gave a fictitious address. When I got to his house, Stryker had hundreds of pictures spread out on a table. He was at his best when dealing with the FSA collection. He was back in the 1930s, I realized. He was directing his old photographers. He was directing me.

You need three things for a great picture, Stryker said. A person, an artifact, and a sign. He told me to look for the significant detail, to learn to take a thousand pictures with my eyes before I took one with a camera. Do you know what makes this a good picture? No? Then don't use it. Look at this fellow with holes in his overalls. He lives beside the road, but he hasn't given up. This is what made America strong enough to win the war. And this housewife in Nebraska. Look at the canned goods she put up. Hope is what you see in these faces. Hope, goddamn it, not the misery those guys at the museum wanted to present. We were supposed to go to the Library of Congress together, to examine the FSA collection, but Stryker wasn't up to it.

I spent two weeks at the Library of Congress looking at the FSA collection of a quarter million images. I came home with 850 Xeroxes and from these Stryker made his final selection for the book. Ah, Dorothea, he said, and gave me an assignment on the migrant camps of California. One time he bundled up all the pictures and put them out for the trash; I retrieved them just as the garbage truck was rattling down the alley. I locked everything in the trunk of my car. One day he went out to get the mail and didn't return; the police brought him home several hours later. I was afraid Stryker would not be able

to finish the book. I wept in my motel room with its green shag carpet and chenille bedspread. I drank Wild Turkey from a plastic cup while listening for the sounds of murderous footsteps outside my window. When I got home, I finished the book, but no one wanted to publish it. My agent begged and pleaded. Finally, the New York Graphic Society decided to take a chance on this now-famous book. Stryker died soon after it came out. He got to hold it in his hands.

A Separate Reality

The photographer and I and our four children lived in a seventeen-room house across from the golf course. Sometimes we couldn't pay the rent; sometimes they shut off the electricity. I sold my grandmother's jewelry and my collection of Navajo rugs to pay the never-ending bills. Sometimes I got in my battered old Mercedes and fled to Taos Pueblo to try to recapture my sanity. Driving into Taos, it was as if a great hand came down to comfort me. I drank in the tranquility of the mountains. I listened to the drums, inhaled the piñon smoke. Something very old and important was happening there. The old Indian told me stories of a time when animals became people and ancestors took form in the stars. Important stuff, yet I couldn't write about it. It wasn't time. I watched and listened and felt the stirrings deep inside.

I stayed with Red Willow Dancing and his wife, sleeping on the dirt floor of their apartment. At night, the men sang and beat the drum to keep the river company. The old man showed me where the old village had been along the river a thousand years ago. A few stubby walls were left. I started to pick up some shards but he told me, sharply, to leave things alone. Sometimes, he'd say something

like, "I am old now and covered with my life" or "All of my life is a dance," which became the first lines of future poems. It was the greatest educational period of my life. I learned about the interconnectedness of birds and grass and clouds and animals.

When I began to understand Taos spiritual belief, I abandoned twenty-five years of Catholicism. How dogmatic it seemed. How punitive. I never went back to the Church. My church was the world around me. Seasons. Sunsets. The birds and animals. I learned to look at the smallest things: the path of an ant across the road, the gentle rhythm of a butterfly's wings. I listened to the language of birds. Red Willow Dancing said they were the messengers telling us to live right. When the sun came up, everyone, including myself, sang to it in a joyous burst of tradition and affirmation. We had strong coffee and bread for breakfast, tortillas and beans for dinner. There was no electricity or running water in the pueblo. I imagined myself in the seventeenth century, baking bread with the shy, self-possessed women I had come to know.

The First Poetry Book

After the success of *Little Wrangler*, the photographer and I signed a contract to do a book on a pueblo boy. Red Willow Dancing's grandson would be our subject, but I couldn't write anything though I wasted hundreds of sheets of paper trying. The photographer took his pictures and waited for me to come up with something. I can't, I said. My mind was blank. When I looked at this kid, I didn't see anything special. How was I to write about his life?

One day I got a stern letter from my editor reminding me that the book was three years late and that if I didn't turn it in within sixty days

Frank Howell and Nancy Wood, photo by R. W. Parker, 1984

I had to pay back the advance. I went into utter panic. We didn't have the money to repay the advance. Do something, the photographer said. I went up into the mountains with my notebook and wrote down what I knew about Taos Pueblo. The stuff about animals and birds. Mountains and continuity. The old man and his family. It took ten days. I filled an entire notebook. It looked like poetry. It *was* poetry. They were short poems because it was a little notebook. So maybe, just maybe, I could send it in and it would satisfy them until I got the real thing done. I typed them up and sent them off to the editor.

"That's not what they want," the photographer said. "Go do the story."

"No," I said. "This *is* the story."

A few weeks later I visited my publisher in New York, nervously chewing my fingernails while I waited. My editor came running out and hugged me.

"No wonder you were three years late," she said breathlessly. "It's wonderful. I love it. Please give us more."

I sent a copy of *Hollering Sun* to Red Willow Dancing, who had introduced me to the Taos way of seeing and believing ten years earlier. When I went to the pueblo, he held up the red-jacketed book. Maybe no white man will understand this book, but an Indian will, he said. He could neither read nor write, but his son read it to him. He and his family signed copies at the local bookstore. The tribal council bought two hundred copies and gave them to tribal members.

At last my career was beginning to take off. I acquired a top New York agent, Marie Rodell. She thought I had a future. She went to work finding a publisher for my material.

"Well, dear," she said in her grandmotherly fashion, "I think you have talent. But you're going to have to work hard. I can't guarantee anything, either."

She became godmother to my middle daughter and put aside a small sum to help with her education. Marie visited us a couple of times a year and we talked about agents, writers, and publishers. I wrote a novel about an alcoholic doctor who kills his best friend, a dying rancher. It was called *The Last Five Dollar Baby*.

About this time I noticed the photographer was sulking. A book of his photographs and my text, *Colorado: Big Mountain Country*, had just been published by Doubleday. It got rave reviews and excellent sales. But it didn't make him happy. He became more and more

withdrawn. He spent long hours away from home, just him and his cameras. Somewhere.

Alone in the World 1969–1976

One hot July day in 1969, when the astronauts blasted off for the moon, the photographer packed his bags and left abruptly. He said he had to be alone to find himself and do the work he knew he could do. He said responsibility deprived him of his destiny. The oldest child was fifteen. The youngest was three.

"What am I to do for money?" I said.

"I can give you two hundred fifty dollars a month," he said. "That's all."

My father, the old kraut who had denied me an education, flew out from New Jersey. In his usual Germanic way he set about making things right. He bought the house for me. When the photographer came to the door, my father slammed it in his face. He landscaped the yard and planted trees; my mother cooked. And pretty soon the four children dried their tears. They learned to make the best of things.

There were times when I felt like running away. There were times when I wondered if the children should go to foster homes. There was no way I could do it alone. I worked fifteen hours a day and got up exhausted. I lost twenty pounds. Pull yourself together, my agent said. She sold my magazine articles and got a contract on *The Last Five Dollar Baby*. It was optioned to the movies but never made. I freelanced for *Empire Magazine* of the *Denver Post*, doing one article a month. I taught a night course in Colorado history at the University of Colorado. I turned eight rooms of the house into an apartment and rented it. My children got scholarships to the exclusive prep schools in the area. And suddenly things didn't look so terrible. I might, in fact, survive.

I began to think of the inner world that was coming to light. I needed isolation, a chance to think. And so I went to Aspen where a friend of mine owned a primitive cabin at eleven thousand feet, nearly at timberline. There was no electricity or running water. I cooked on a woodstove, hauled water from the stream, and chased porcupines out of the entryway at night. Bears came by to visit, also elk and skunks, badgers and marmots. There were two waterfalls a short distance from the cabin and I watched them intently, gradually seeing the pattern of the water as it crashed. I welcomed the peace, the expansion of my senses. I began to write poems for the next book, *Many Winters*, only this time I would have an artist illustrate it, not the photographer.

On my way home, I stopped on top of Independence Pass on the Continental Divide at twelve thousand feet. I got out of my car and drank in the view. The mountains stretched on and on. The cold wind blew. The landscape was barren and rocky, covered with tiny flowers. The wind was fierce. I put on my parka and hood, gloves, and warm boots. When I got to the ridge, away from people, I began to dance, and the mountains took me into themselves and told me it was all right. I have been dancing on top of Independence Pass for thirty years, in my purple silk dress, humming Mozart's Horn Concerto. It replenishes me like nothing else on earth.

Hold on to what is good
even if it is
a handful of earth.

Hold on to what you believe

even if it is

a tree which stands by itself.

Hold on to what you must do

even if it is

a long way from here.

Hold on to life even when

it is easier letting go.

Hold on to my hand even when

I have gone away from you

This is the last poem in *Many Winters*, the one most anthologized and quoted at memorial services (also the one most frequently used without permission). When I do my dance on Independence Pass, I think of this poem. This is where I want my ashes scattered. This is where I am most connected to the earth. Hold on.

I had my women friends during those stressful years, three lusty college professors who were a lot like me. We called ourselves the Gang of Four, and every Friday we met at someone's house, drank martinis, smoked dope, and ate a potluck supper. We talked about men, what bums they were, and how we were never going to have anything to do with them again. Of course, I had lots to do with them, a new one every month or so. My sexual liberation was underway along with the freeing of my soul. It made me write better. In time, I was glad the photographer had left. It liberated me in so many ways, even though my children thought I was whacked out and unpredictable. Be normal, they said, but of course I couldn't. It was too late.

When *Many Winters* was finished, a friend recommended well-known artist Frank Howell. He was an intense man of great talent and passion who painted stylized portraits of Indians. He lived in Breckenridge, Colorado, where he had an art gallery. He'd ride his motorcycle to the top of Wilkerson Pass, where I waited in my car, to show me the work he'd done. I had a new agent by then. She sold this book to Doubleday. It became a classic, famous throughout the world. Frank and I did four more books together, each more spectacular than the one preceding it. The sales were unprecedented—nearly half a million copies with large sales in Japan. Frank died in 1998 of a brain tumor. A new hole developed in my life.

The Stryker Legacy

Fate is strange sometimes. I hardly ever thought about photography in the early 1970s, but one day, while working for Bill Moyers on a movie he was making in northwestern Colorado, he asked me to take some still pictures with his Nikon. I had no idea what I was doing, but I pointed it and shot anyway. Cowboys riding horses. Cowboys smoking cigarettes. Cowboys and old buildings. Not too bad. Not too good. I made Moyers some prints for publicity purposes and filed the negatives away. I forgot about them for several years.

Nineteen seventy-six was Colorado's centennial year. All sorts of nonsensical things were being funded—a costume ball, a miners' parade, a mock shootout, very little lasting or important. I got out the box of Stryker's FSA shooting scripts with which he directed the photographers on their far-flung assignments. "What do people do in the evening?" he wrote. "Where do they gather? What does the

Nancy Wood and her three husbands,
photo by Kate Wood, 1981

local justice system look like? Take pictures of harvest, one-room schools, if there are any. Get to the heart of the region."

From the Moyers contact sheets I selected half a dozen images that were sharp, had them printed, and presented them, along with an adaptation of the shooting scripts, to the Colorado Centennial Commission. I waited. It was insane. Audacious. I would be found out. I should withdraw my application. What was I thinking of? It was as bad as my pretending to be a travel correspondent. I looked at Stryker's picture on the dust jacket of our book. Do it, he said.

One day I got a phone call informing me that I was the recipient of a twelve-thousand-dollar matching centennial grant in photography. For this princely sum I was expected to photograph rural Colorado for a year, mount an exhibition at the Colorado Heritage Center, and publish the work, not to mention manage my time and ongoing expenses at home. It was impossible. Consider the fact that I knew nothing about the technical side of photography, only the

aesthetics that Stryker had taught me and the practical experience my former husband had imbued in me. I was in over my head. I didn't know an f-stop from a bus stop. I would confess my ignorance and give the money back. Instead I went to a trusted photographer friend and he gave me secret photography lessons: how to load the camera, how to take the film out. I bought a couple of Pentaxes with zoom lenses; one body held Tri-X film, the other Plus-X. I shot no color. I didn't see the world in color, just as my former husband hadn't seen in color. I bought a big map of Colorado and tacked it up on the wall of my studio. I divided the state into six sections. I thought, well, I'll just do one section at a time, starting with the plains. The criterion was that a town couldn't have traffic lights or parking meters. I set out in my Subaru station wagon, armed with film and water and snacks, also a topo map of the county I was going to. Panic seized me. What was I doing at the county fair in Deer Trail? With trembling hands, I took my first pictures. Mailboxes. A feed store. An old lady in front of her house. A dust storm on the plains. But I also had to write stuff down, including peoples' names, what they said, and the names of the towns I went to.

It was on-the-job training. The early pictures were underexposed, overexposed, out of focus; often my thumb got in the way. But then, after a couple of weeks, I began to get the hang of it. Roy Stryker would have been proud. Years ago he'd taught me the art of seeing. He said the camera didn't matter; it was the eye that counted. I had the eye, didn't I? I could pick out good subjects. I knew how to use light. I kept the shooting scripts in my camera bag and referred to them as I went along. In Wild Horse I found a dilapidated gas station run by a middle-aged couple; in Pueblo, at the Cheat 'Em and Chisel

'Em Market, the subject was straight out of FSA. I noticed an old homestead on the windswept prairie, the way the sun dappled the cornfields. I found people in cafés, gas stations, schoolhouses, courthouses. I became less nervous. I made fewer mistakes.

Stryker's daughter, Phyllis Wilson, was still in Grand Junction. I wrote to her:

> Your father gave me much more than I ever realized, not just the work we did together on the book, but a whole new way of looking at people and situations. Because of him, a new career has opened up for me. I have been photographing an FSA-type project for about a year now, but more and more, as I understand the way he taught me to see, I can honestly say that Roy has had the greatest influence on my life of anyone in the world. He was a great teacher and a great human being. I remember certain things he said to me, certain ways he wanted me to look at pictures, and the driving force he used to make me realize I am somebody. He believed in me.

Six months into the project, I realized that the money would soon run out. It cost money to process film and make contact sheets and work prints. It cost money for gasoline and meals and motels, not to mention childcare and expenses back home. I would have to abandon the project and tell the commission I couldn't go on. I was broke. The story of my life.

One day I was photographing a ranch near Ramah, a big spread owned by a tall Texan in a cowboy hat. He was a Yale graduate, part of a prestigious old Texas cattle family. He looked at my photographs. He liked them.

"Why don't you stay a while?" he said. Days passed, then weeks. He flew me to all parts of the state in his Twin Bonanza. He talked the language of ranchers and helped me to put them at ease. I learned more than I ever cared to know about cattle. I rode a horse, more or less. I got to like cowboys even if I didn't share their political views.

Antonito. Alamosa. San Antonio. Dolores. Rico. Cortez. Cripple Creek. Victor. Hugo. Simla. Pueblo. Rangely. Westcliffe. Wild Horse. The National Western Stock Show. County fairs. A rural homegrown wedding. A judge in bib overalls. I branched out to the Ute reservations. No one had ever photographed them in depth before. Edward Curtis couldn't even find them. I photographed the chairman of the Ute Mountain Utes. An Indian high school graduation. Babies. Grandmothers. The peyote chief. Women playing cards at the Bear Dance.

The project spilled into 1977. Even then, working full-time, I covered only a fraction of the state though I traveled over fifteen thousand miles and shot twelve thousand images. The cost of the project skyrocketed. The rancher took up the slack. I had bitten off more than I could chew. But the photographs were unique. I had gotten the hang of it. Stryker would have been proud.

The Marlboro Man

The rancher and I married in June 1977 and I entered a world of privilege and money. I could have spent my time doing nothing, but I had an exhibition to prepare for the State Historical Society, a book to write for Harper and Row. I took some of my best photographs in the

latter part of that year. The rancher was proud of me. But tension rose between us. I was uneasy living amidst such wealth; I hadn't earned it. By now I was writing a book on the Utes, and had written another novel, which Doubleday published. One day I rode out across the fourteen-thousand-acre ranch admiring the shimmering beauty of sunlight on grass, the white clouds billowing up. A coyote darted across my path, looking over its shoulder at me. An eagle soared overhead, uttering a strange, screeching call. I realized that my time in this place was winding down. Perhaps I felt compromised by old Republican money; perhaps I was afraid of losing my soul.

I got off my horse and wrote a poem about the sacredness of the land. I would miss this special place with its rocks and trees and gently rolling hills. For five years I'd been taken care of by someone who thought he loved me. I'd gained insight into the heart of a man accustomed to luxury. I wrote one poem, then another. They were different from the Taos poems. I had never tackled the Utes before. The poems were the basis for the next book, *War Cry on a Prayer Feather*, based on the complex Ute cosmology. It was set to music and nominated for a Pulitzer Prize. The music was for orchestra, tire chains, garbage pail lids, chorus, and vacuum cleaner. It was performed in Colorado Springs, Oakland, and New York. I went once to hear it. I hope it is buried somewhere in the annals of music disasters.

Changing Woman

By 1983, Red Willow Dancing had died. I wrote a short novel in his honor, *The Man Who Gave Thunder to the Earth*. I spent time with his family behind the pueblo walls. One day, the Indians and I were sitting at the dining room table. There was going to be a family wedding. Would I come down and photograph it? I hadn't taken any pictures in six years, and never any at Taos Pueblo, but I said yes. For three days I photographed the bride and groom, friends and relatives. I shot fifteen rolls of poignant, unstaged subjects—three men with a baby, an older couple obviously in love, elders, children, men in blankets, women in shawls. When the contact sheets came back, I looked at them in amazement. Here was a unique and powerful study of a major Indian culture. The people were so real, at ease and unpretentious. Something in me stirred. I *had* to photograph Taos Pueblo before everything changed. I saw my last child off to college and sold my house. This was what I would use to fund my project and if the money ran out, I'd think of something. I rented a U-Haul and dragged my stuff to Taos. I rented a crumbling adobe house with vigas and a tamped earth floor. Every day I drove to the pueblo. I had no shooting script; I waited for something to happen. Woman baking bread. A man teaching his son to plant corn, an old woman picking wild flowers. The Indians were unconcerned with my camera. I photographed everyday life: a baptism, doing laundry with an outside machine, children at Christmas. I took extensive notes, struck by the cultural shifts taking place—the rarity of Tiwa being spoken, the changes in dress from what I remembered twenty-five years earlier. No more horses and wagons in the plaza, but pickups, boom boxes, and more vendors. I noticed the plaster falling off. Many houses were vacant. People lived in prefab BIA houses now. I was witness to what anthropologists call acculturation. Tourists streamed into the pueblo, hundreds of them per day, paying ten dollars at the gate. I watched them with their Instamatics trying to capture what I was

Nancy Wood dancing on top of the Continental Divide at twelve thousand feet. Photo by Mary Eshbaugh Hayes, 1994

trying to do. In shorts and T-shirts, often with a yapping pueblo dog at their heels, they swarmed across the plaza in search of an Indian Disneyland. Who was I to think I was recording something exclusive? I kept on, filled with urgency and despair.

Somewhere around this time, I wrote a novel about the crucifixion of a priest in New Mexico in 1895. Called *The Soledad Crucifixion*, it was a magical realism book that examined the conflict between Catholicism and Indian religion, something on which I had become a bit of an expert. In my tale, the Indians converted the priest who loved women, fathered children, and drank heavily—in other words, a typical priest. I worked on this book when I wasn't photographing the pueblo. It was something I had to do. The manuscript grew to eight hundred pages. One day, the phone rang. It was the National Endowment for the Arts. They had awarded me a literature fellowship based on the bizarre first chapter of the priest hanging on the cross. They sent me a check for twenty thousand dollars, to spend as I wished. To this day I don't remember applying to them.

I had mixed feelings about doing any more work at Taos Pueblo because the commercialization was so obvious. An Indian friend of mine said, look, you're making a record for our children. The tourists don't do that. This time I concentrated on the old people, a 103-year-old man and his drum, a woman drawing her dreams in the dust with a stick, traditional women hanging on to the old ways of their grandmothers. I knew that what I was photographing was destined to pass from the scene. I worked hard to get it all recorded, realizing I never could. But I was burned out. I wanted to move to Santa Fe where my then-boyfriend lived. Alfred Knopf published the book, *Taos Pueblo*. The Museum of Indian Arts and Culture

used eighty of my Taos images as their inaugural exhibition in 1989. I wondered what project to do next.

While I was immersed in the pueblo, I'd signed a contract with the University of New Mexico Press to do a book called *Heartland New Mexico: Photographs from the Farm Security Administration, 1935–1943.* I knew the material; all I had to do was retrace the steps of Dorothea Lange and Arthur Rothstein on the plains, John Collier in Hispanic villages, and Russell Lee in Pie Town. I felt Roy Stryker at my elbow. One more book, he said. And take plenty of pictures. I set out for Springer and traveled east across the desolate plains. A few farms here and there, broken fences, deserted homesteads. Nothing was left of the towns that Rothstein and Lange photographed. I went to Pie Town. Three of the original homesteaders that Russell Lee had photographed were still there, more than forty years later. It was richer than I could have possibly dreamed. I photographed them extensively and took notes. The original shooting script for Pie Town was in my head. I took hundreds of photographs, including the old cook who baked the pies of Pie Town, in 1940. I made one more trip to the Library of Congress and selected several hundred New Mexico FSA images.

The Museum of Fine Arts decided to do an exhibition of these FSA images. Russell Lee came up from Austin to help with this selection. So this was the famous photographer of whom Stryker once said, "Russell is the son I never had." Tall, courtly, and at peace with himself, Russell, then in his eighties, raised a toast to Roy Stryker, as did John Collier, who came down from Taos to offer his views on picture selection. The three of us took a drive out past Galisteo and they told me stories of what working with Stryker had been like. He knew what he wanted, Russell said. Demanding, John Collier said. Later, John took me to the Hispanic villages of Las Trampas and Truchas where many of the original families he'd photographed in 1943 still lived in simple adobe houses. I photographed them too. I have my own FSA record and you can see similarities, and perhaps Stryker's ghost hovering in the background.

Full Circle

I'm almost as old now as Stryker was when I met him. I'm the same age as Red Willow Dancing was when I first climbed up the ladder to his house. I'm what's called an elder, though I don't feel like an elder except when my bones creak and I can't walk as far as I used to. I take no photographs anymore, having completed everything I wanted to say. I write fiction and poetry and sometimes a children's book, though I don't even want to do that anymore. I live near the wilderness with coyotes and ravens and the vast land falling away and the great bowl of the sky pressing down. I have a few good friends and the children I thought would never grow up have children of their own. It's enough to make anyone happy, even an old curmudgeon like me.

NANCY WOOD
Santa Fe, New Mexico
January 2007

EYE OF THE WEST

PHOTOGRAPHS BY NANCY WOOD

THE GRASS ROOTS PEOPLE

The person I remember most from the Grass Roots People project is Minford Beard of Elk Springs, in northwestern Colorado. He'd been a cowboy all his life, and he could ride and rope and brand as good as any man. He was easy in the saddle because he'd been born to it; his oneness with the horse was what I noticed first when I went to take his picture. Minford, in chaps, boots with spurs, and a cowboy hat that never blew off, galloped across the sagebrush at breakneck speed, sailing over arroyos so fast that I, trailing along behind on a old, safe horse, saw only a blur. The immense Piceance Basin stretched endlessly in all directions. The wind yelped out of the north, and I was cold. We were after wild horses. Most of the time I got to sit behind a V-shaped brush trap while Minford and three of his friends drove the horses in. They were magnificent creatures with fiery eyes and sharp hooves. He

caught a little filly for my daughter, going on ten. She rode it for the next four years.

That night we sat around the dining room table. On the wall were trophies from his hunting expeditions: a zebra, a cape buffalo, a lion, a bighorn sheep. Minford said, "When I die I want my body tanned and made into a woman's riding saddle. That way I'll always be between the two things I love the most, a good horse and a beautiful woman." He laughed and laughed.

The Grass Roots People were different from other people. They were survivors. They were stubborn. Mostly they were conservative Christians. I began to see that no matter what they were, they were the backbone of the West. And I tried, as the months swept by, to immortalize them in my photographs. By the time the project ended, most of them had passed on.

Minford Beard, 1974

Boyd Walker, Browns Park, Colorado, 1976

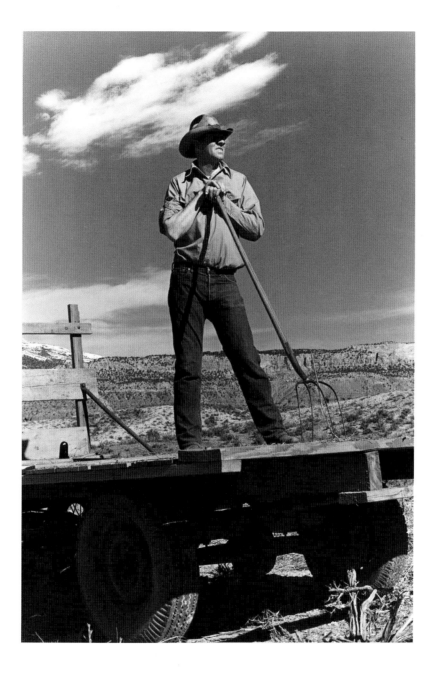

Monty Sheridan, rancher, Rangely, Colorado, 1974

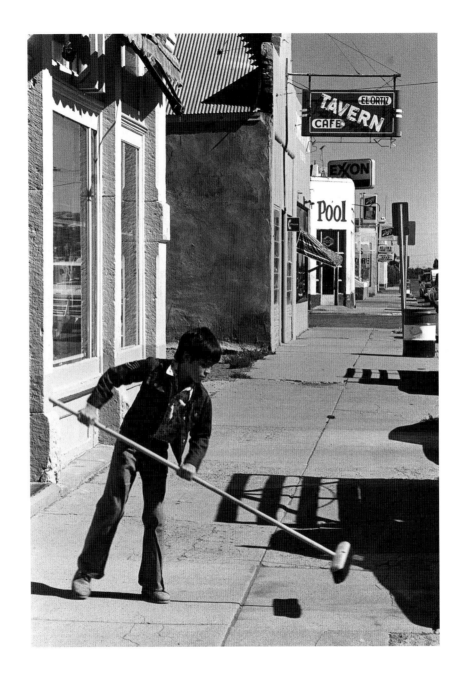

Main Street, Antonito, Colorado, 1976

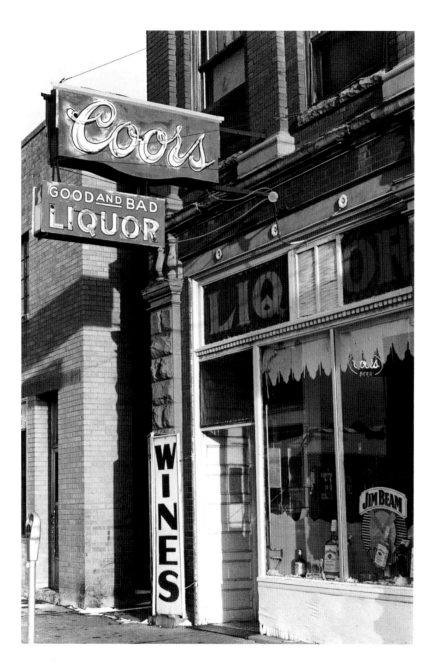

Main Street, Trinidad, Colorado, 1975

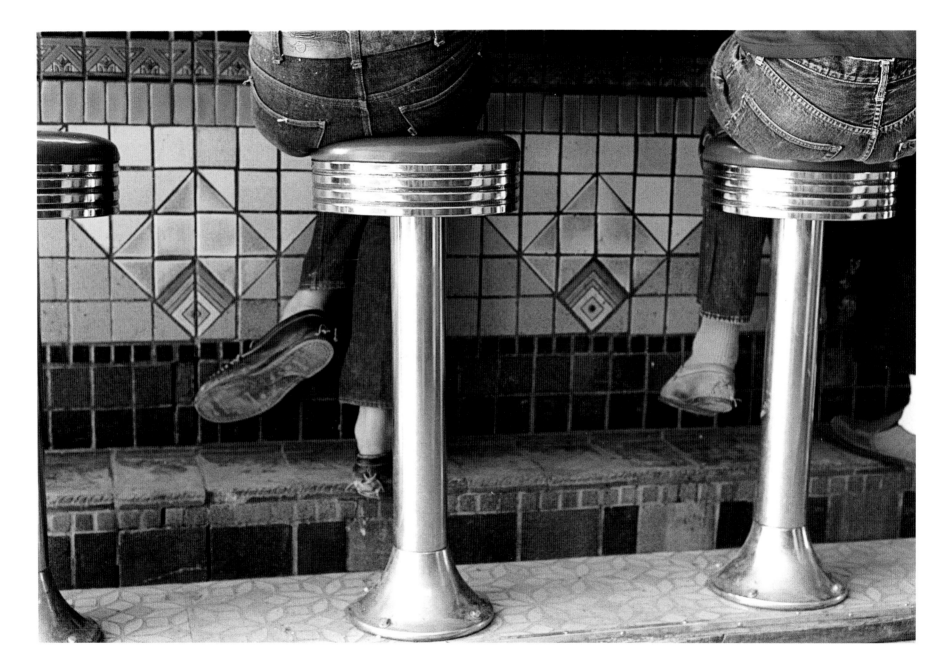

Drugstore, Creede, Colorado, 1976

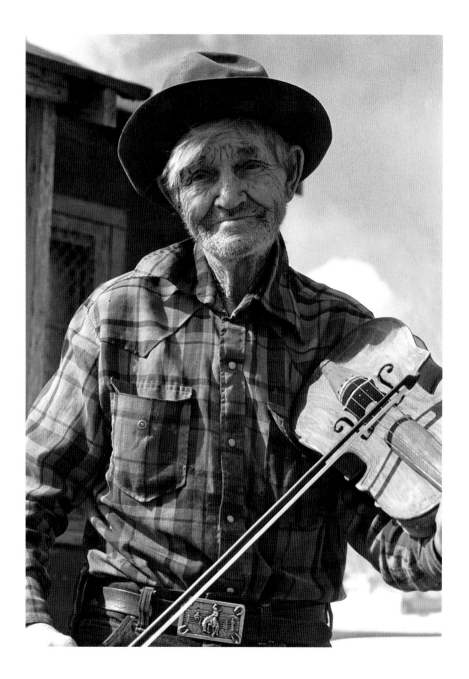

Ben Gillespie, fiddle maker, Dinosaur, Colorado, 1976

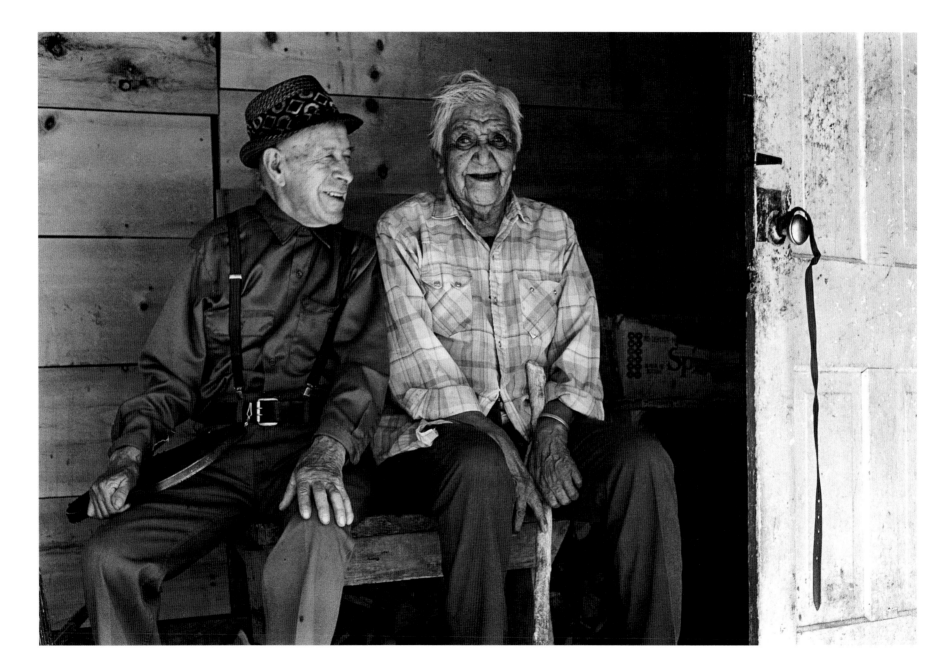

Felix Gomez and Juan Jose Peña, Pagosa Junction, Colorado, 1976

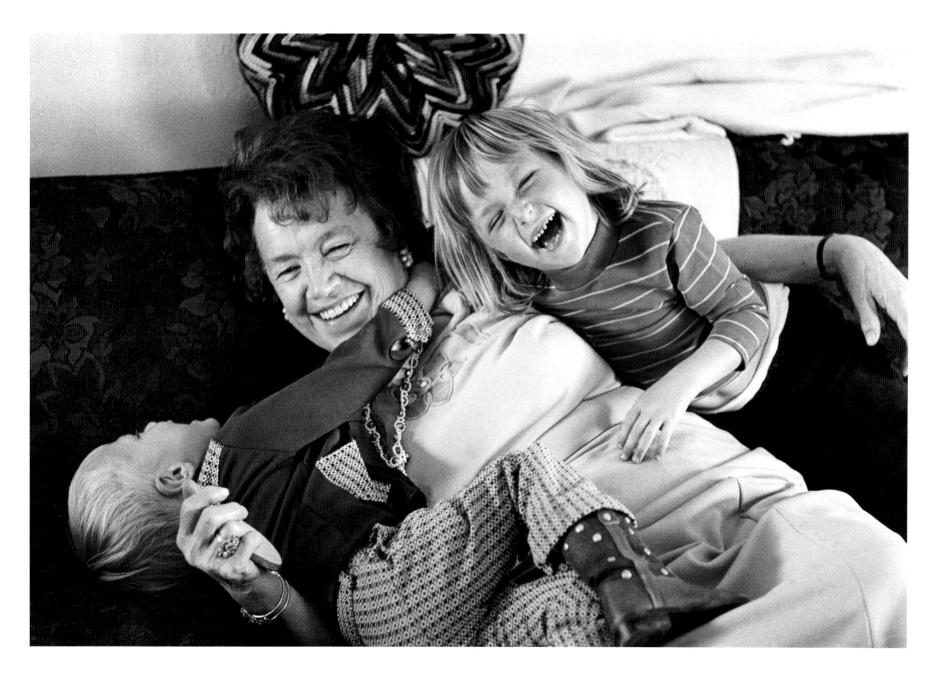

Mildred Mikita and grandchildren, Simla, Colorado, 1976

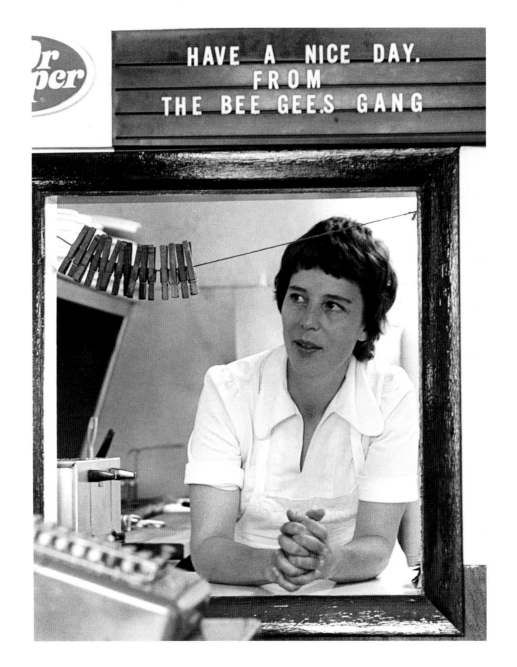

Bee Gee's Café, Alamosa, Colorado, 1976

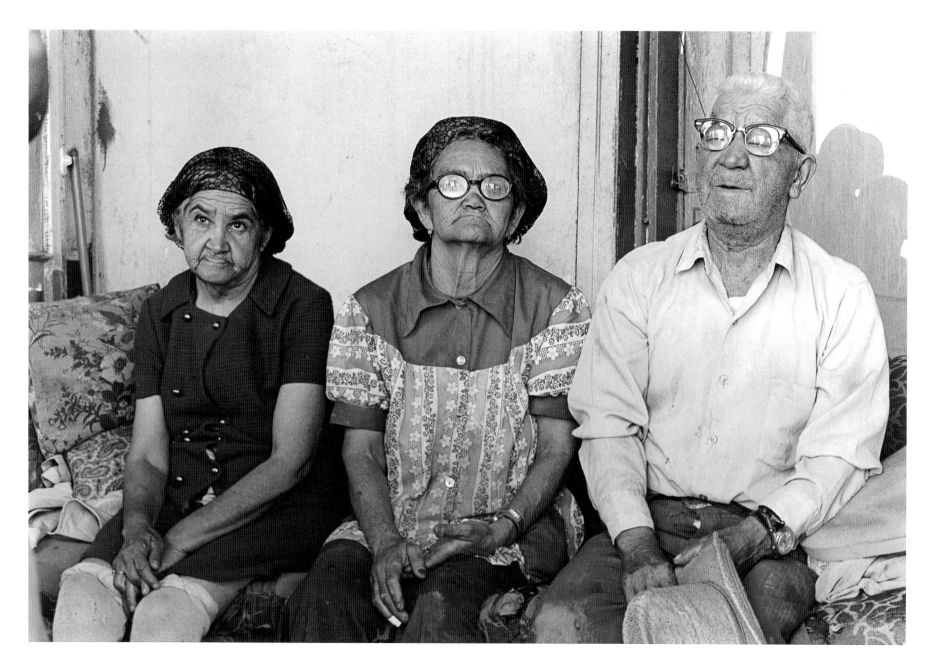

Mr. and Mrs. Herminio Mares, and friend, Lobatos, Colorado, 1976

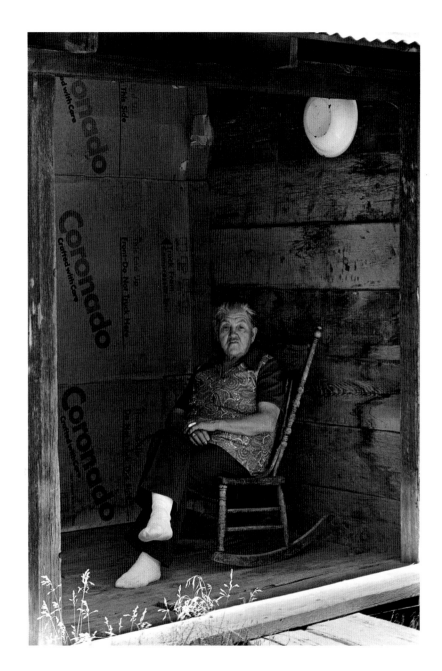

Mrs. Augustine Villareal, Pagosa Junction, Colorado, 1976

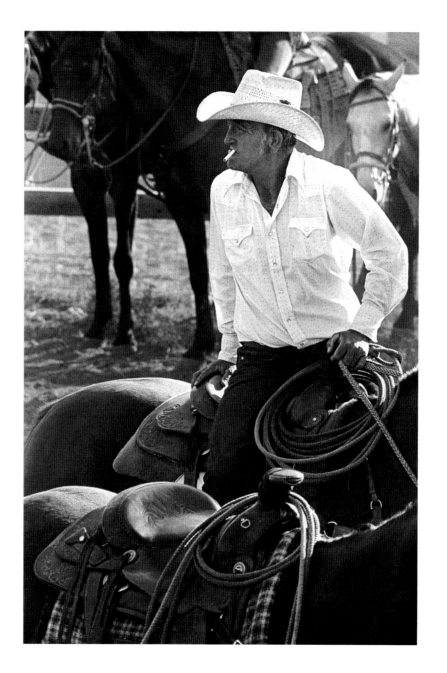

Boots Brinkley, rodeo cowboy, Peyton, Colorado, 1977

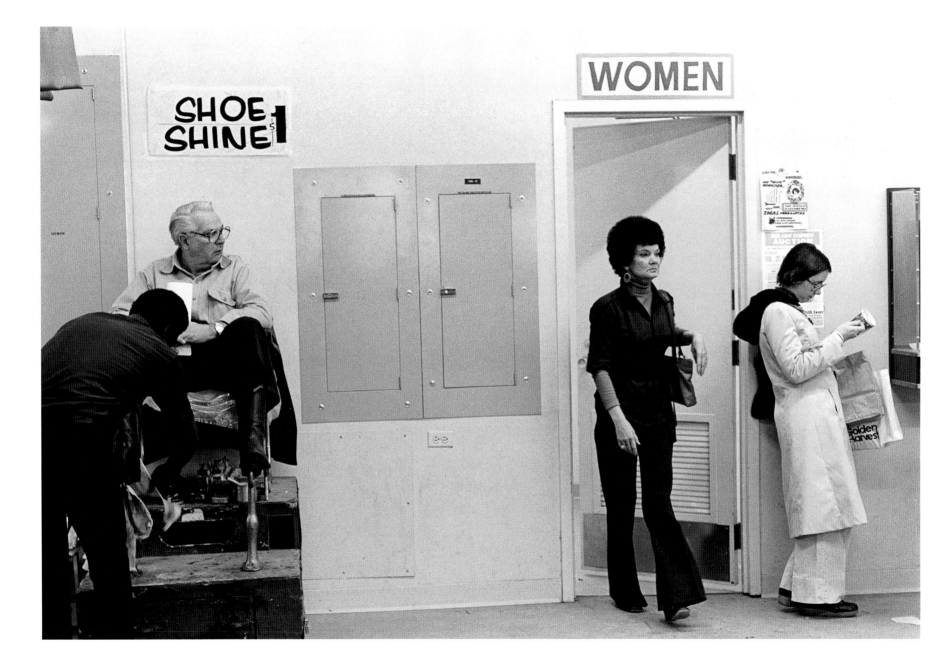

Denver Western Stock Show, 1977

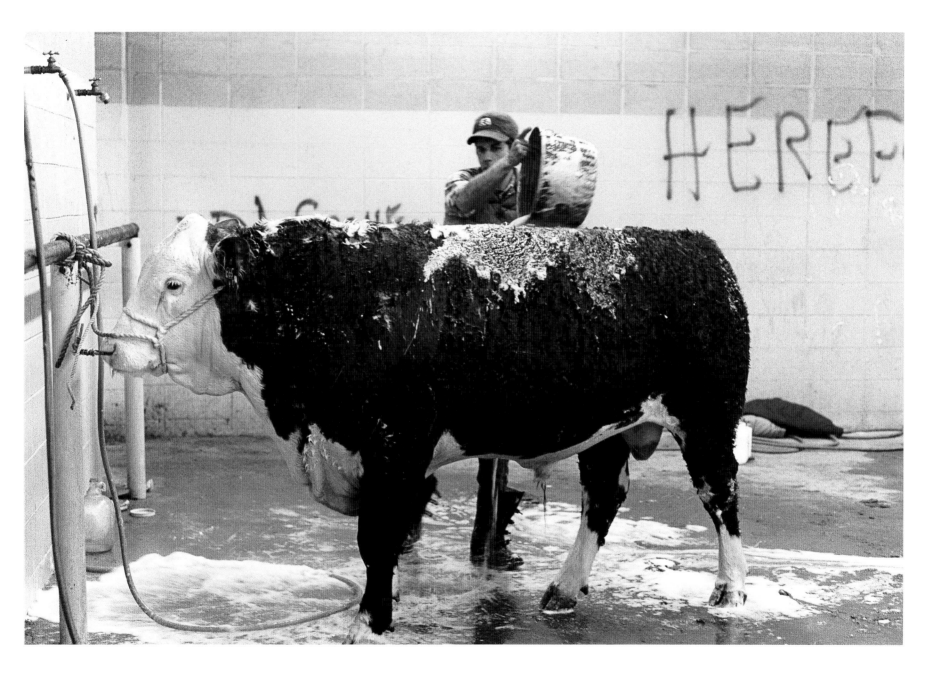

Denver Western Stock Show, 1978

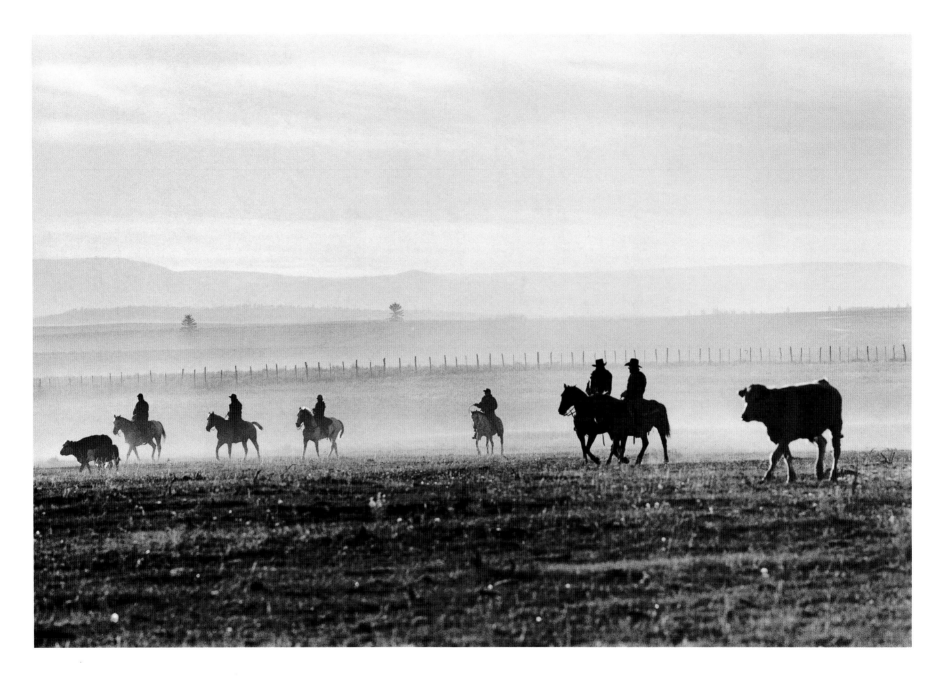

Ute Mountain Ute ranch, Gunnison, Colorado, 1978

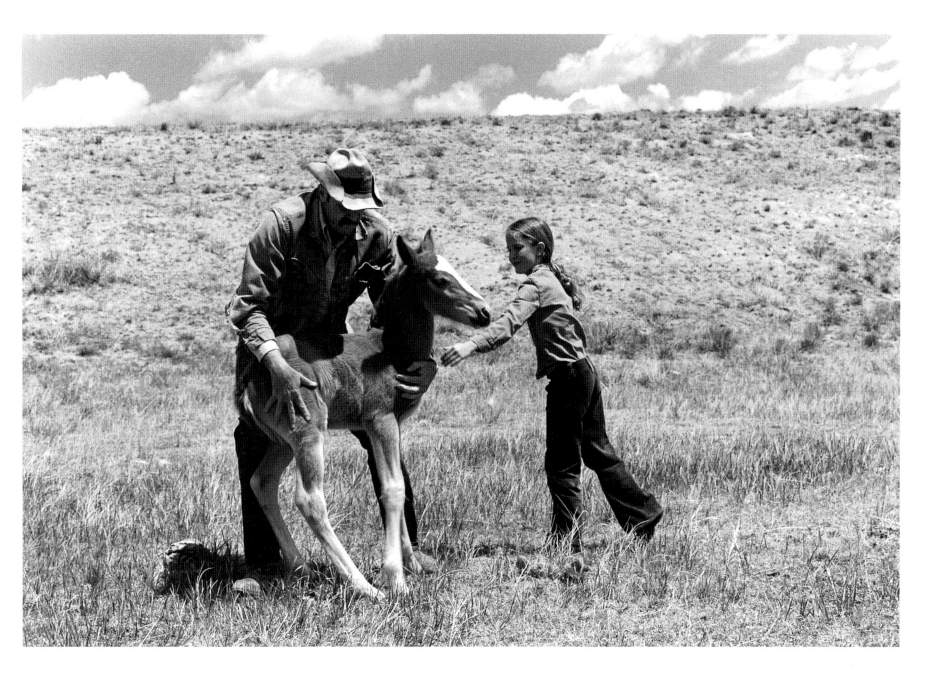

John Brittingham and stepdaughter India Wood, Ramah, Colorado, 1976

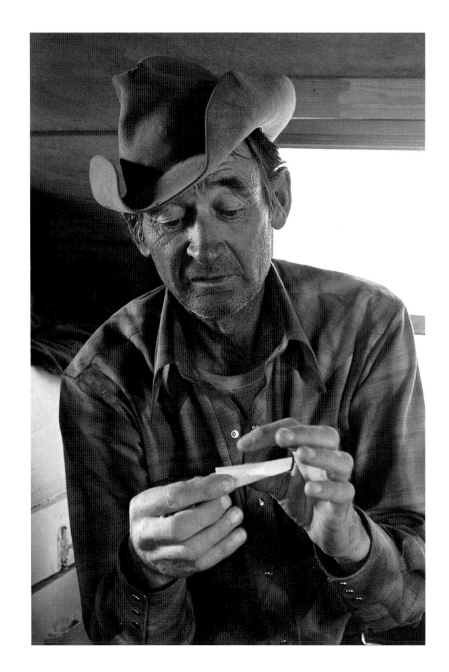

Parl Jackson, Rangely, Colorado, 1976

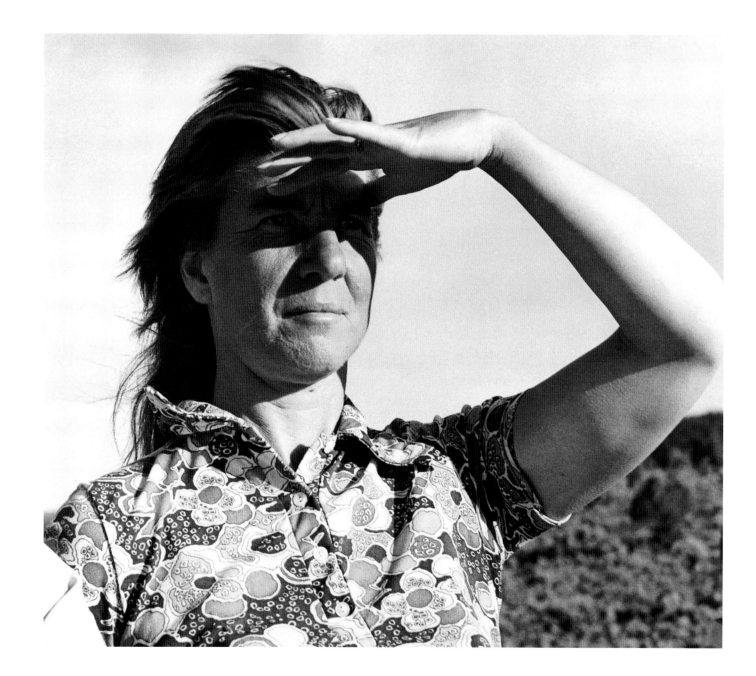

Louise Foster, rancher's wife, Douglas Mountain, Colorado, 1975

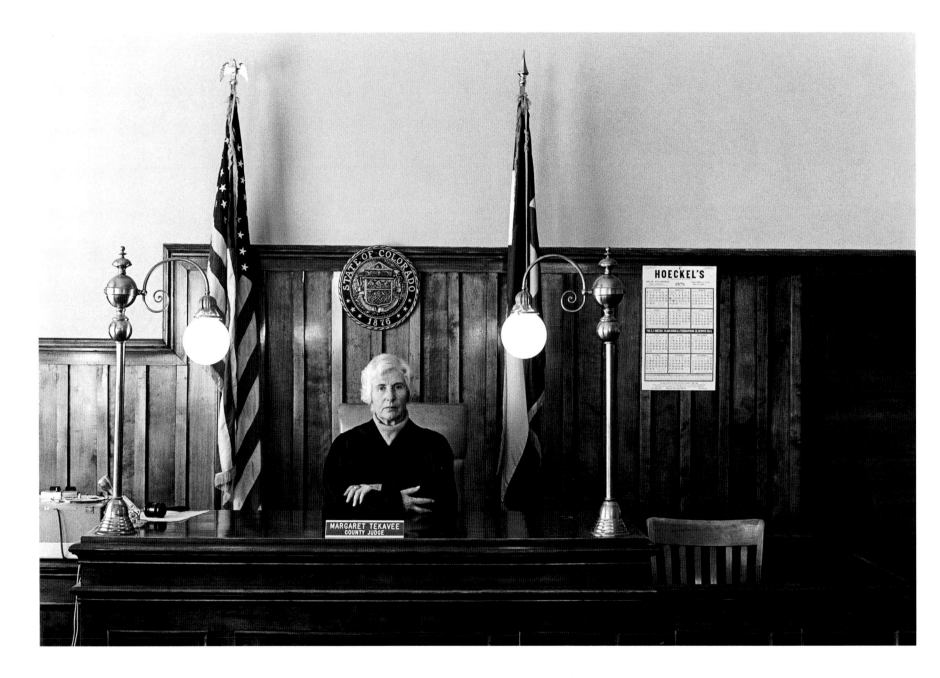

Judge Margaret Tekavee, Cripple Creek, Colorado, 1977

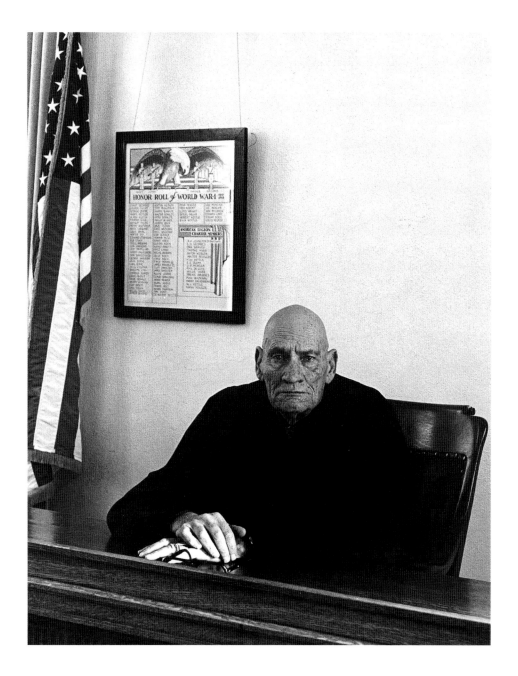

August Menzel, municipal judge, Westcliffe, Colorado, 1976

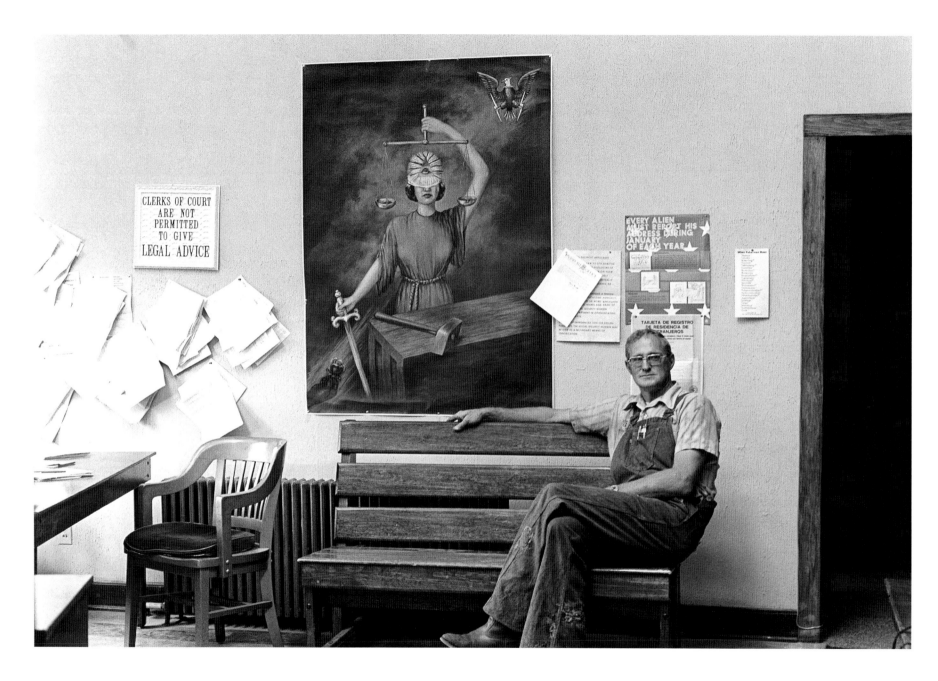

Bob Wordell, municipal judge, Creede, Colorado, 1976

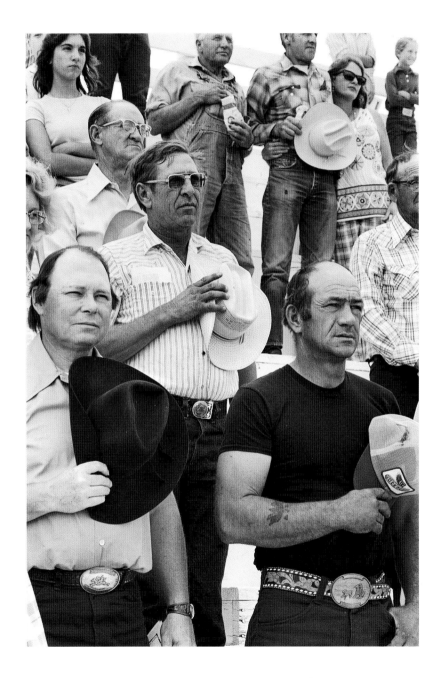

Flag salute, Deer Trail Rodeo, Deer Trail, Colorado, 1976

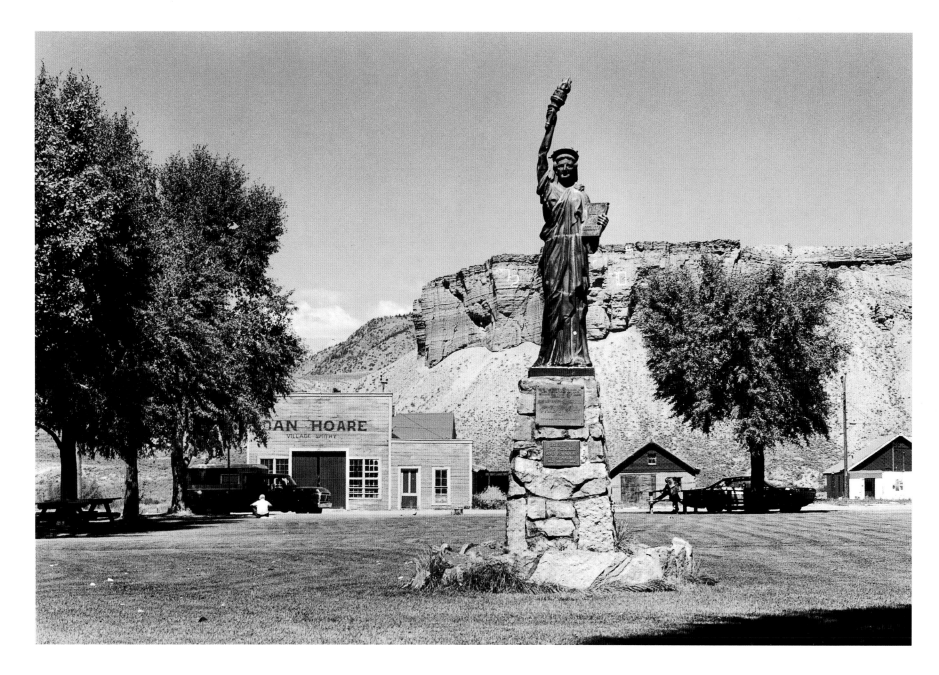

Statue of Liberty, Kremmling, Colorado, 1976

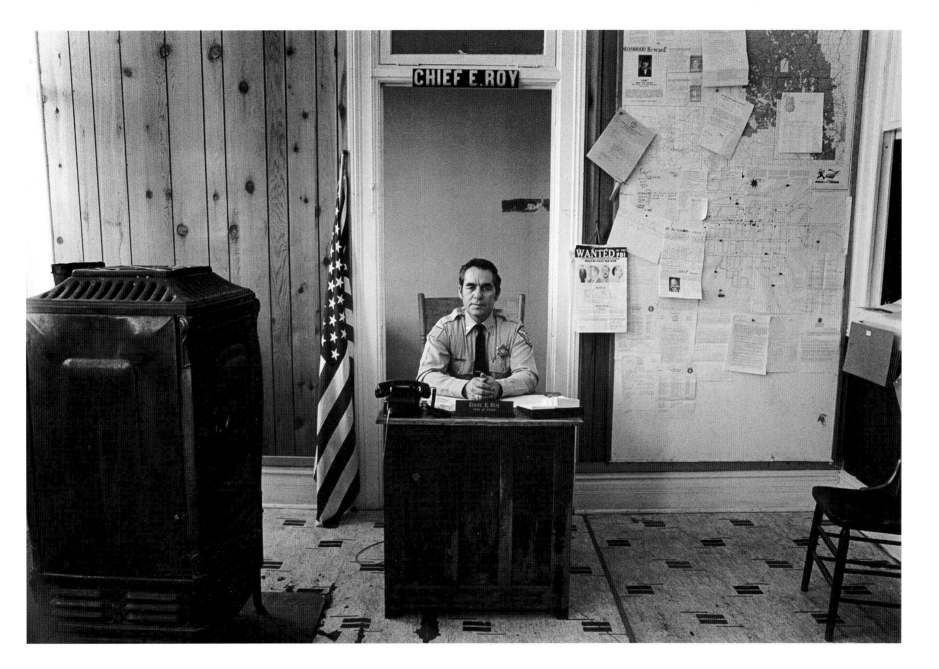

Eddie Roy, chief of police, Victor, Colorado, 1978

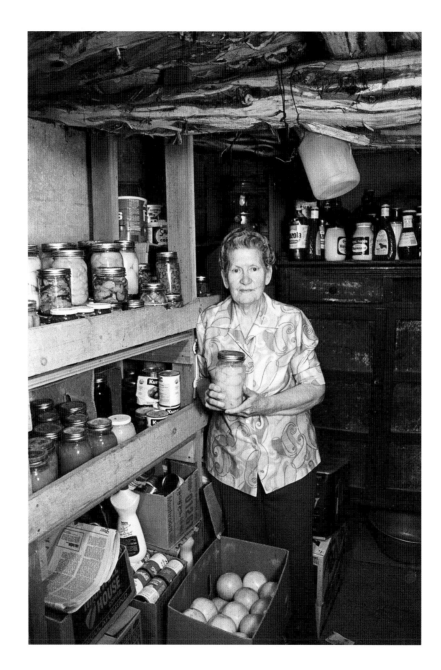

Ruby Kirby, housewife, Rangely, Colorado, 1976

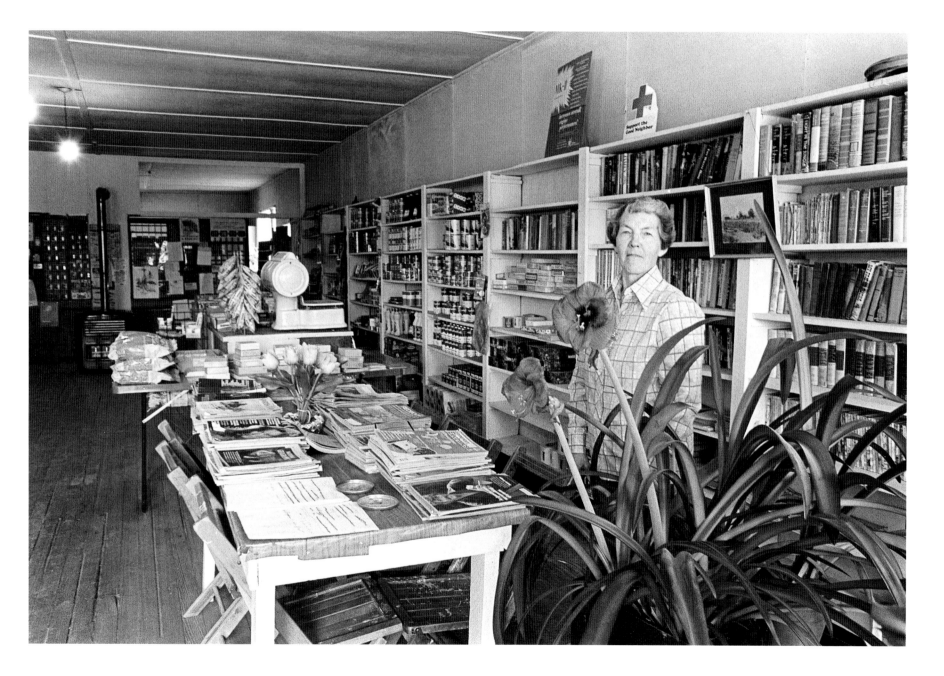

Blanche Devore, postmistress, Vernon, Colorado, 1977

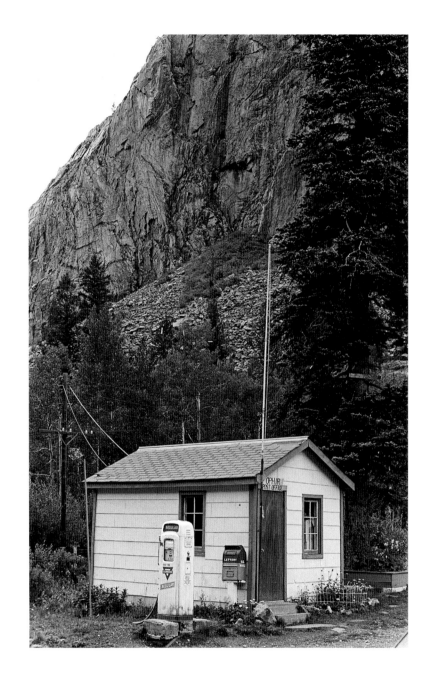

Ophir, Colorado, Post Office, 1977

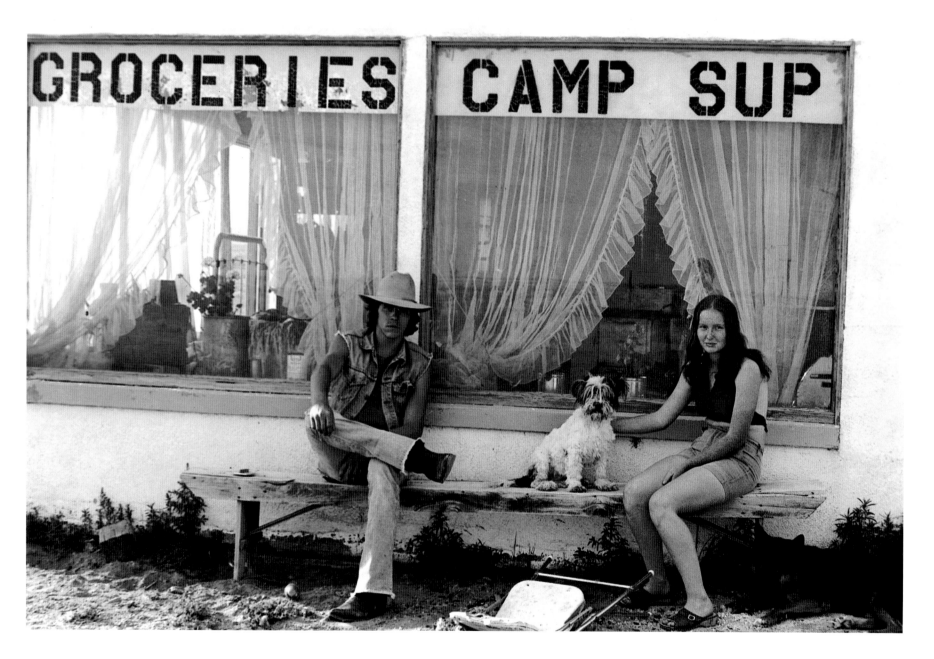

Hippies, Villa Grove, Colorado, 1976

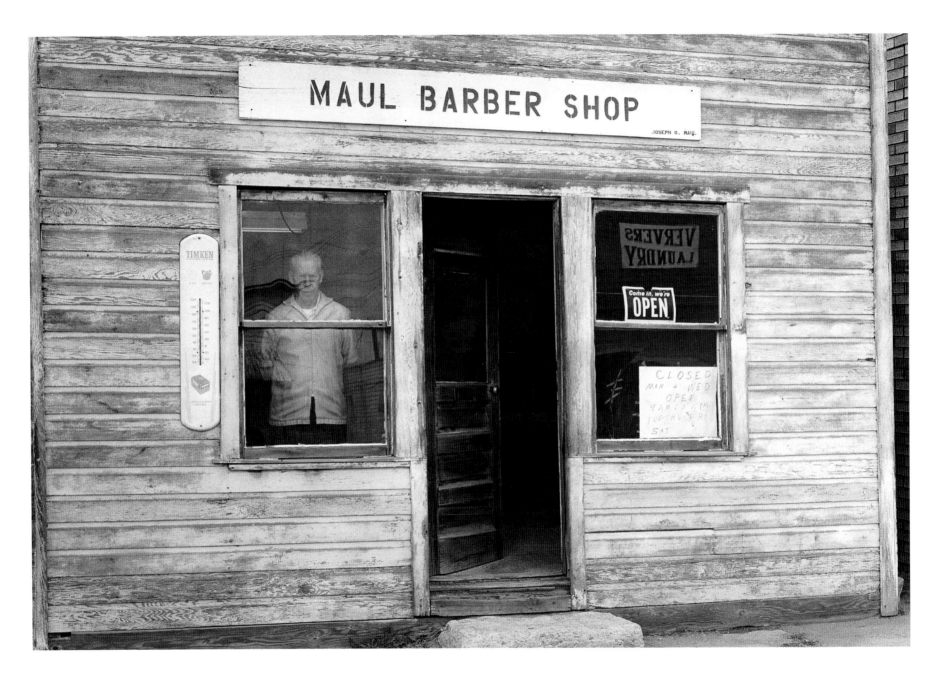

Maul barbershop, Calhan, Colorado, 1976

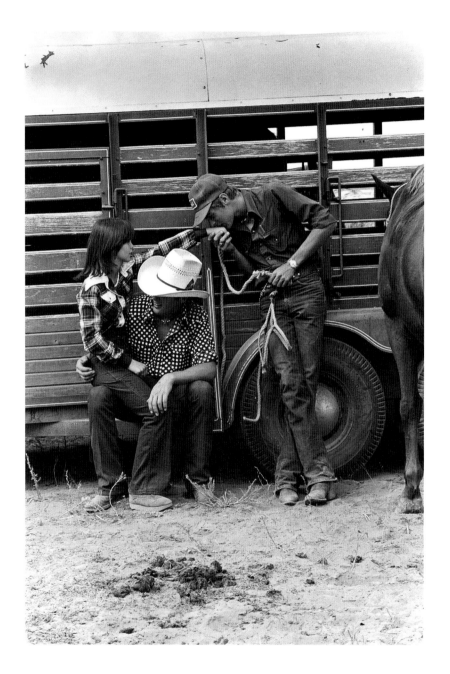

Deer Trail Rodeo, Deer Trail, Colorado, 1976

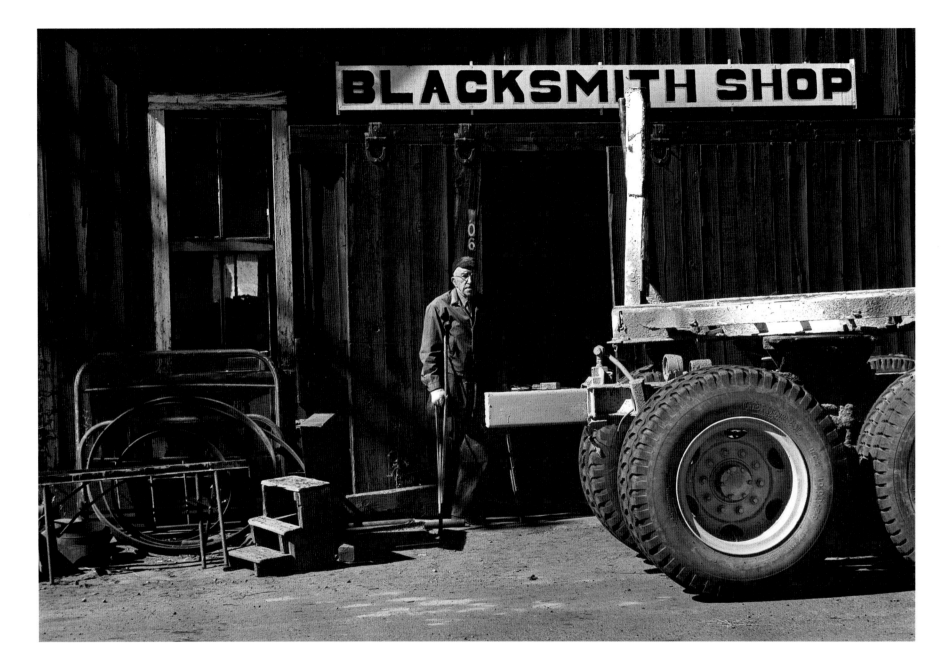

One-legged blacksmith, Rico, Colorado, 1975

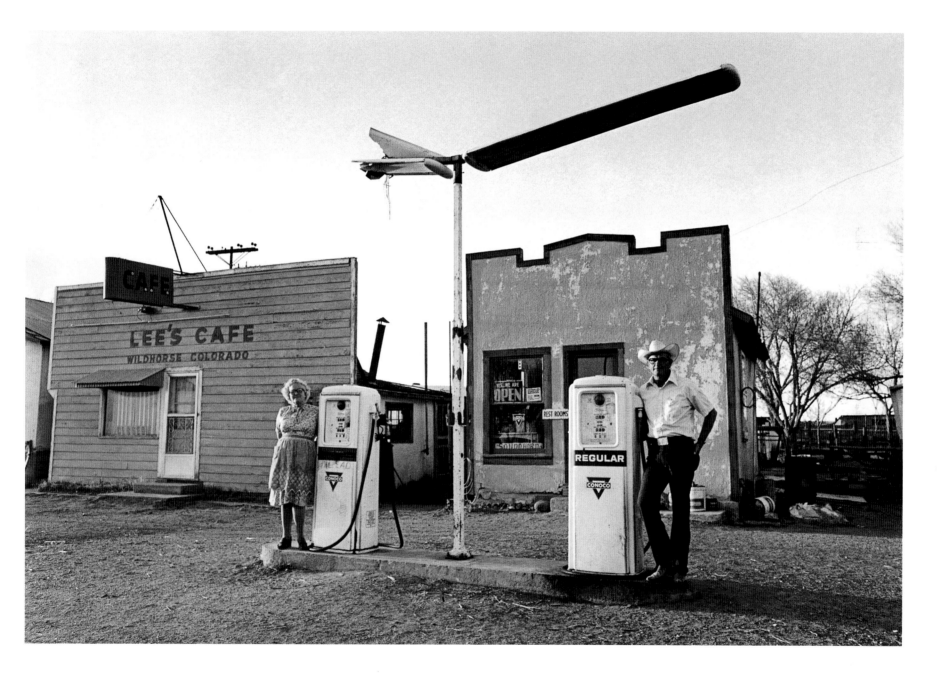

Leona and Curtis Schrimp, Wild Horse, Colorado, population twelve, 1978

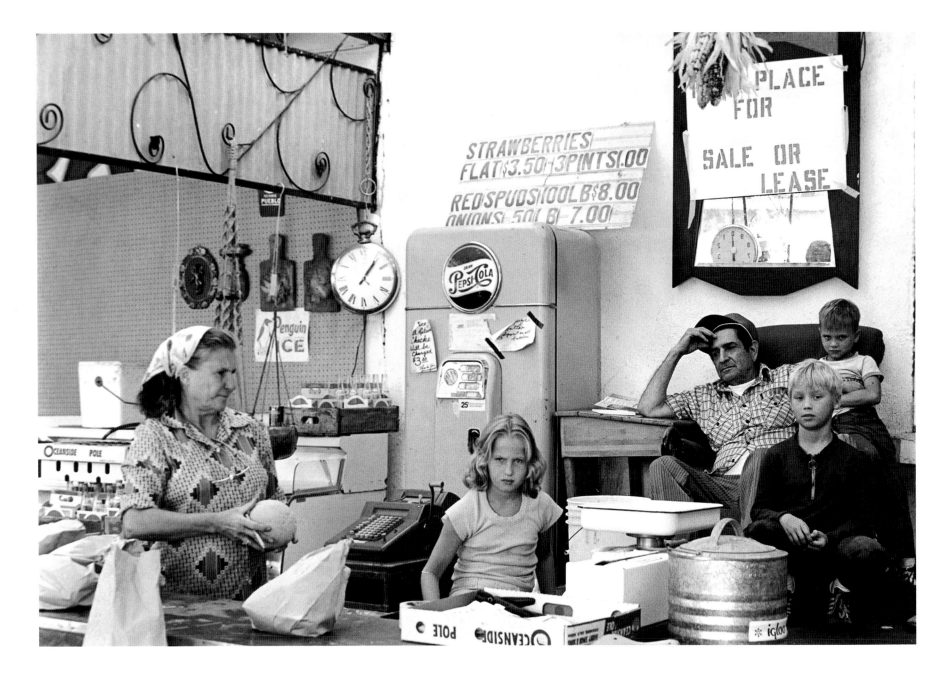

Cheat 'Em and Chisel 'Em Market, Pueblo, Colorado, 1976

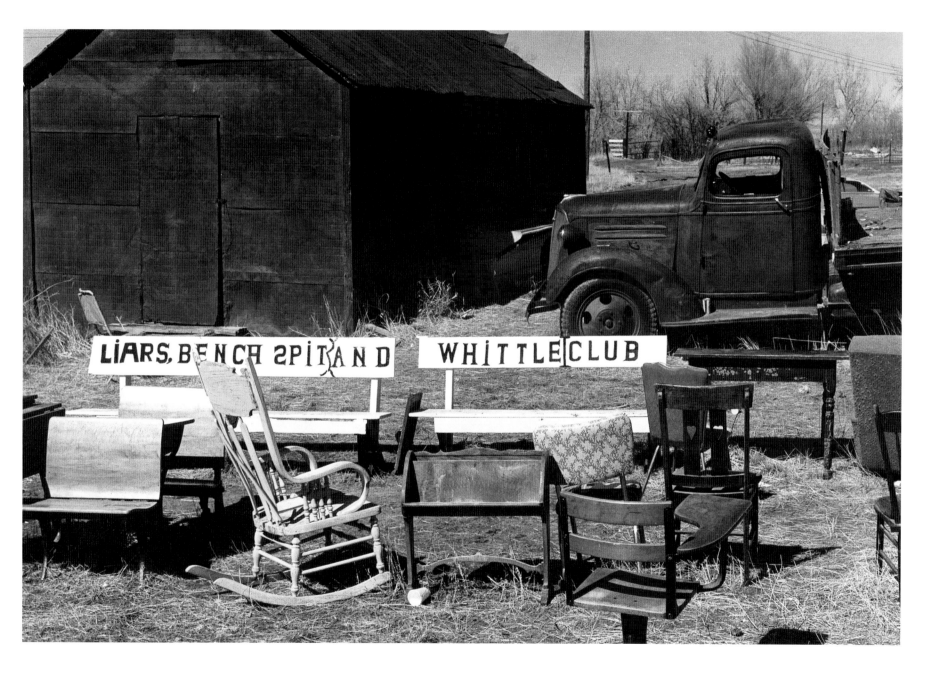

Farm auction, Ramah, Colorado, 1976

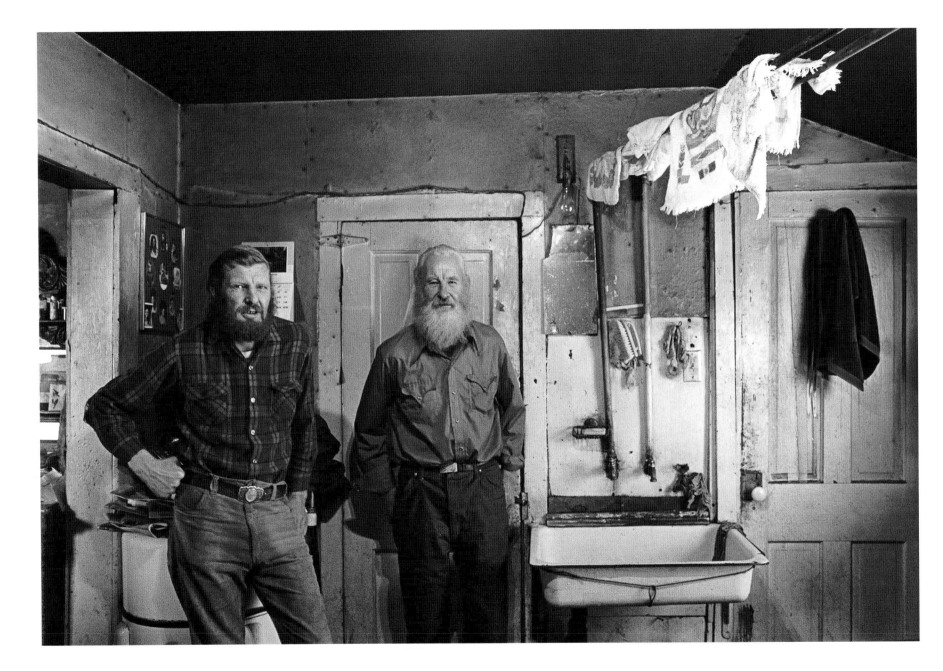

John and Albert Nothaus, miners, Goldfield, Colorado, 1978

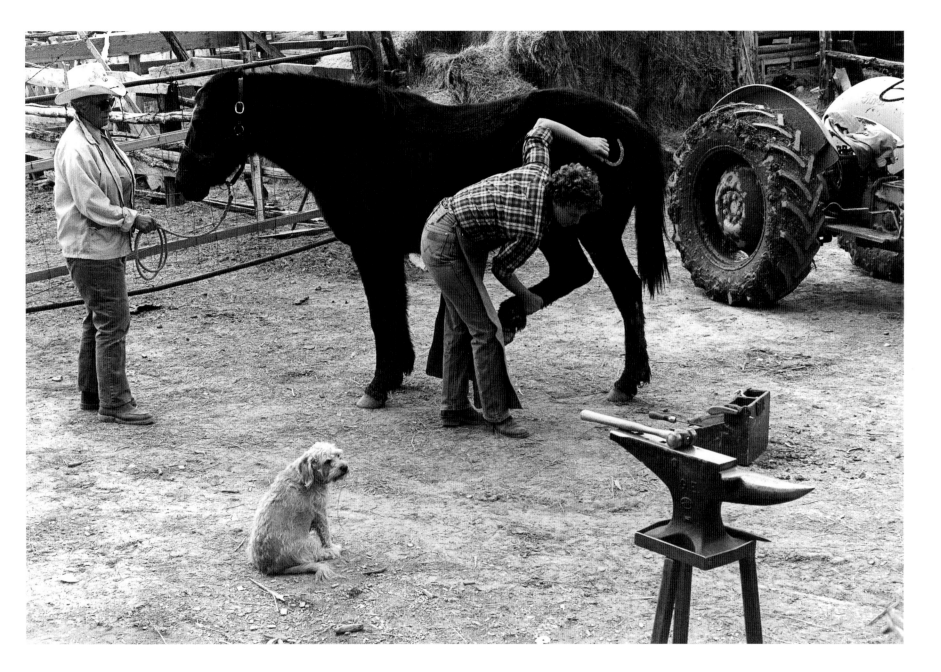

Ada Gates, horseshoer, Montrose, Colorado, 1976

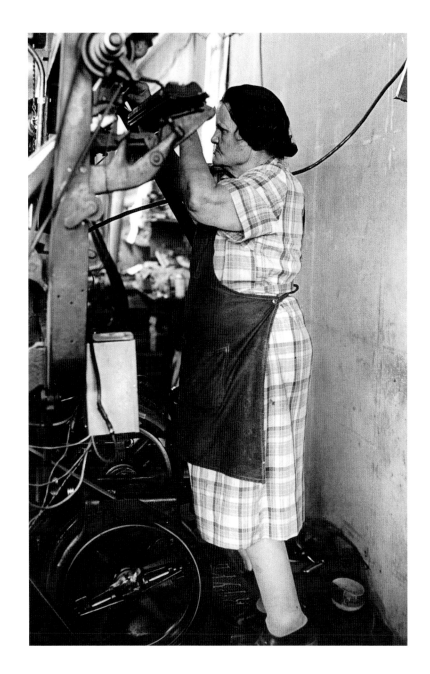

Mary Mudd, publisher of the *La Jara Gazette*, San Luis Valley, Colorado, 1976

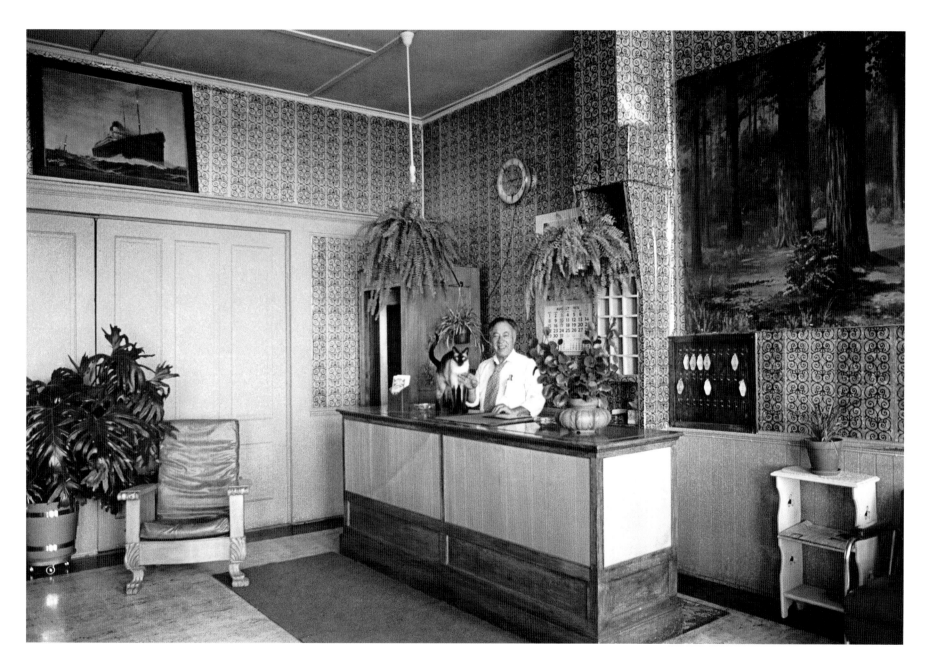

Tony Lucero, owner of the Palace Hotel in Antonito, Colorado, 1976

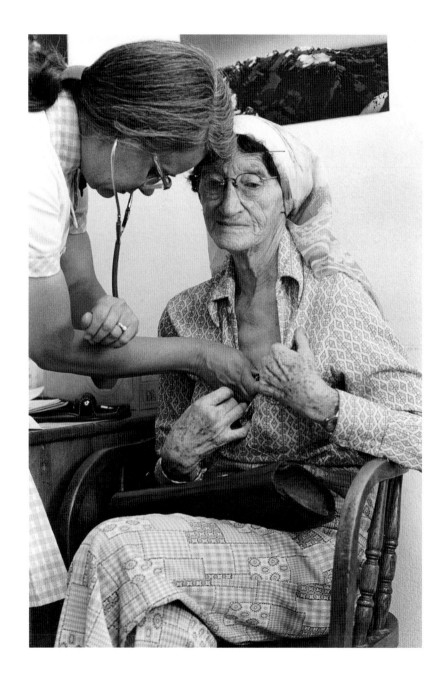

Dr. Karen Dolby, Westcliffe, Colorado, 1977

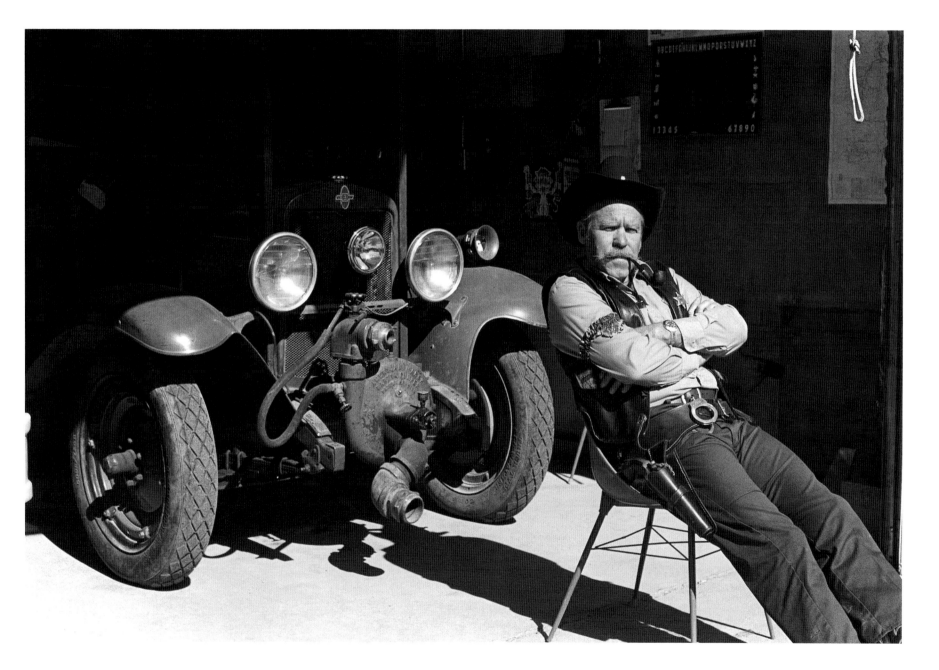

Donovan Cullings, town marshal, Creede, Colorado, 1976

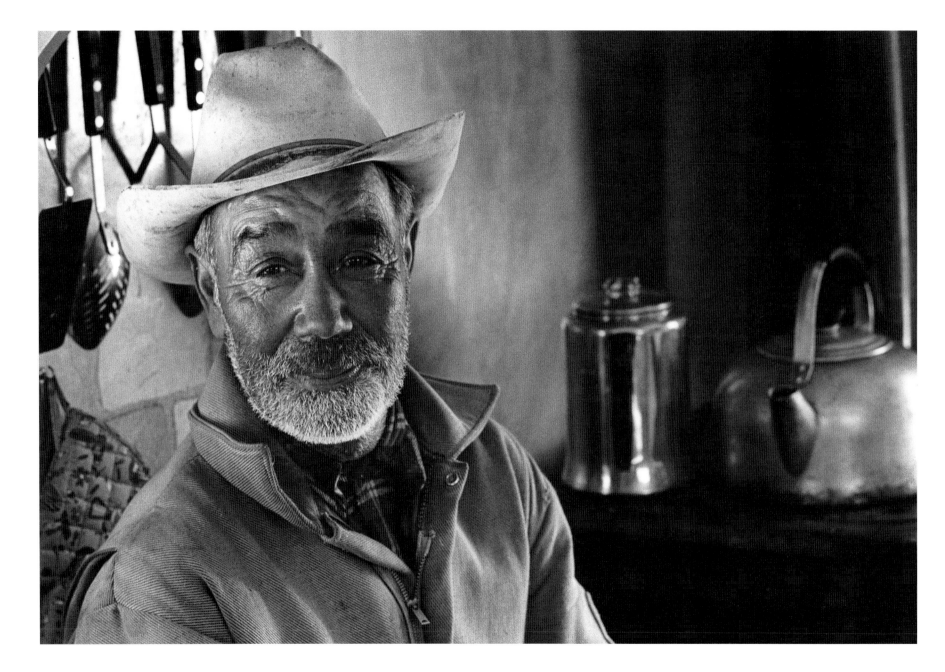

Justo Mofin, sheepherder, Rangely, Colorado, 1976

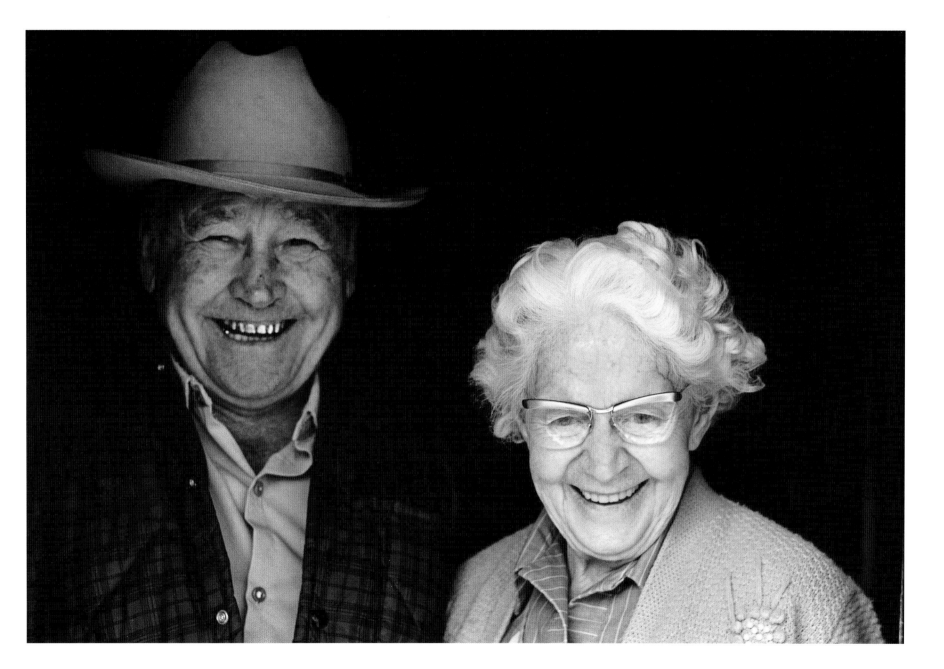

Mr. and Mrs. Robert Jones, ranchers, Wray, Colorado, 1976

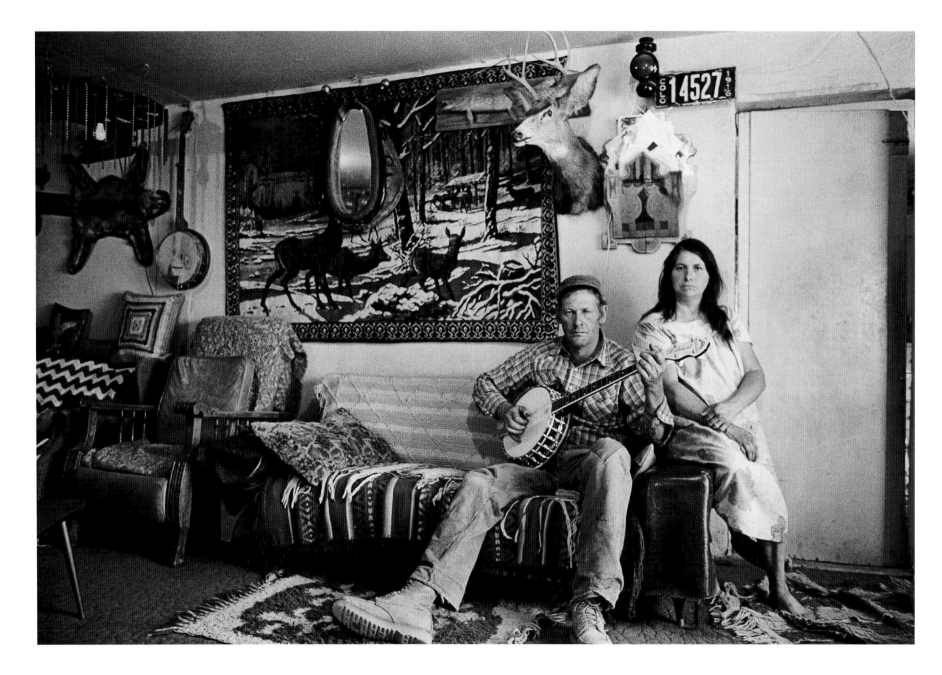

Ocie and Robert Young, Squaw Point, Colorado, 1977

Howard, Colorado, 1976

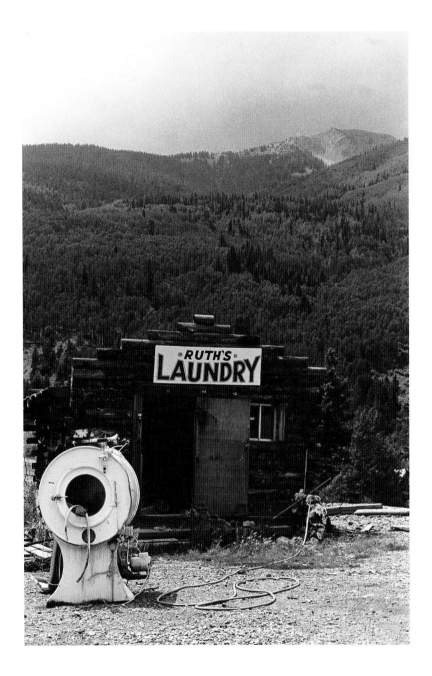

Ruth's Laundry, Rico, Colorado, 1976

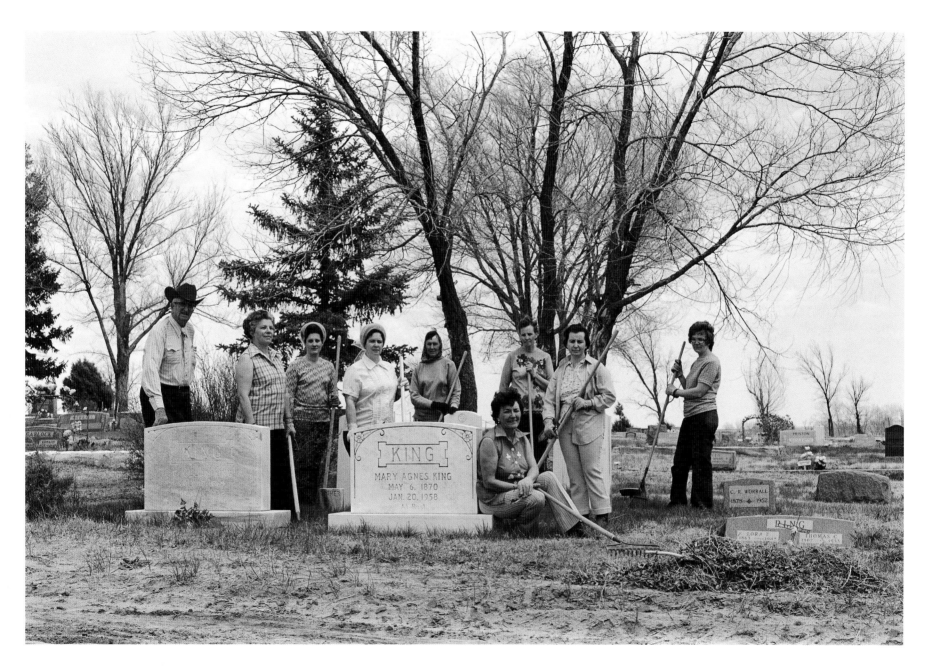

Women cleaning a cemetery in Simla, Colorado, 1977

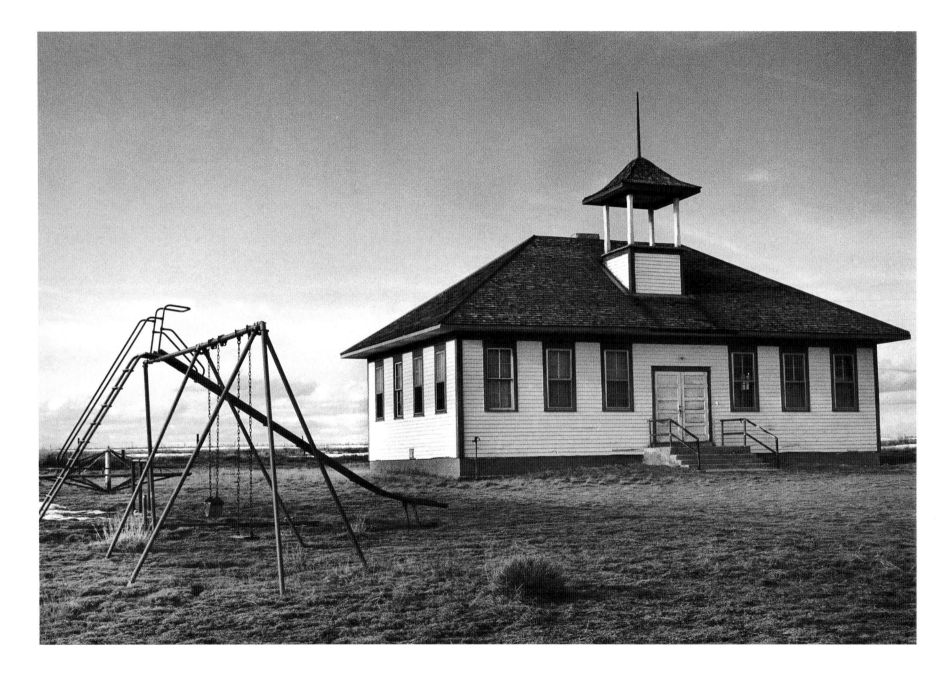

Wild Horse one-room schoolhouse, 1978

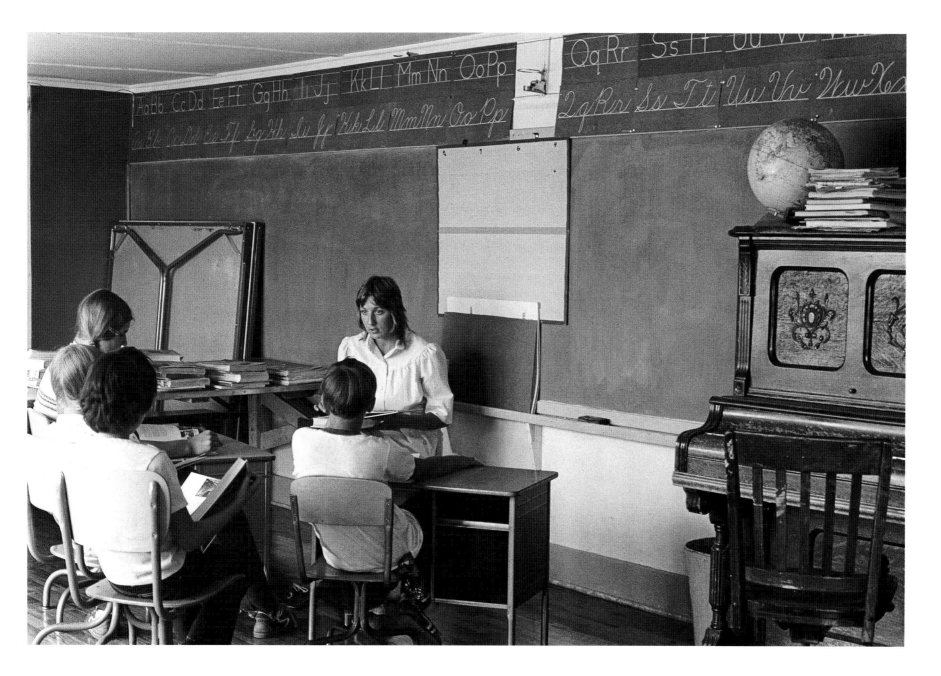

Browns Park one-room schoolhouse, 1977

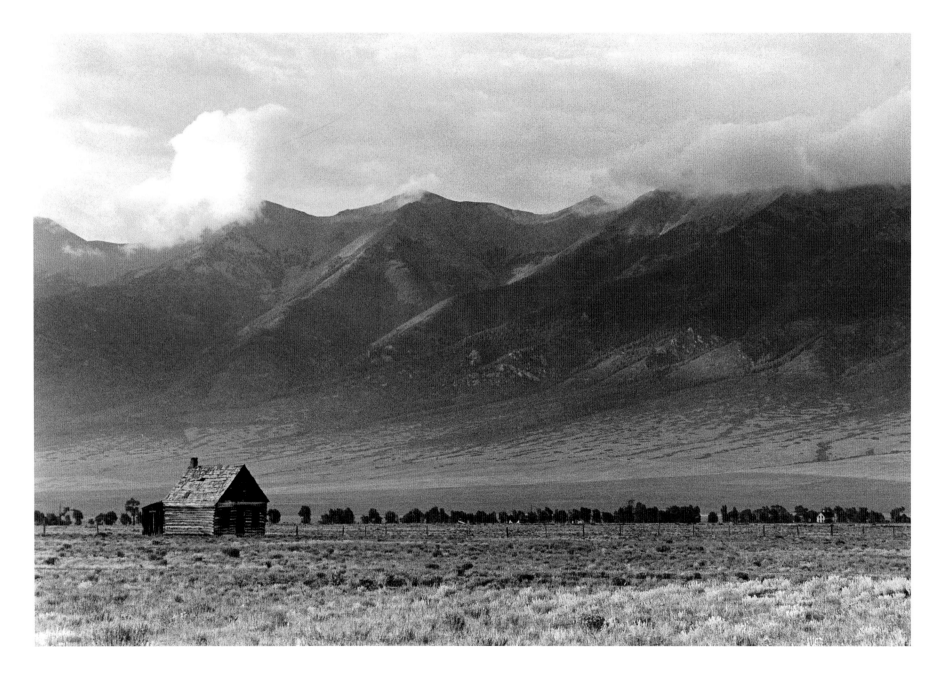

Abandoned homestead, Villa Grove, San Luis Valley, Colorado, 1976

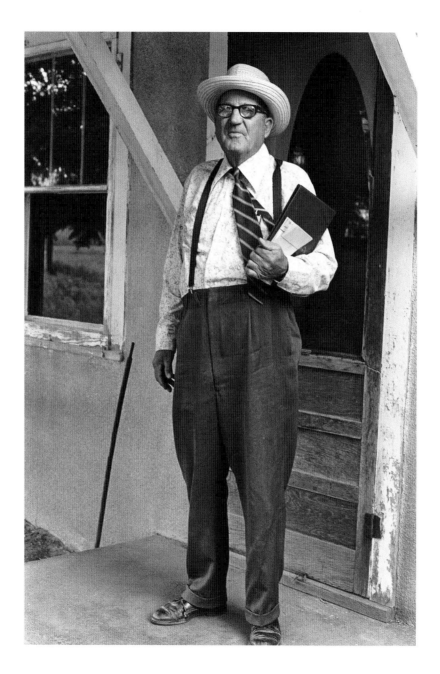

Fuller brush man, Strasburg, Colorado, 1976

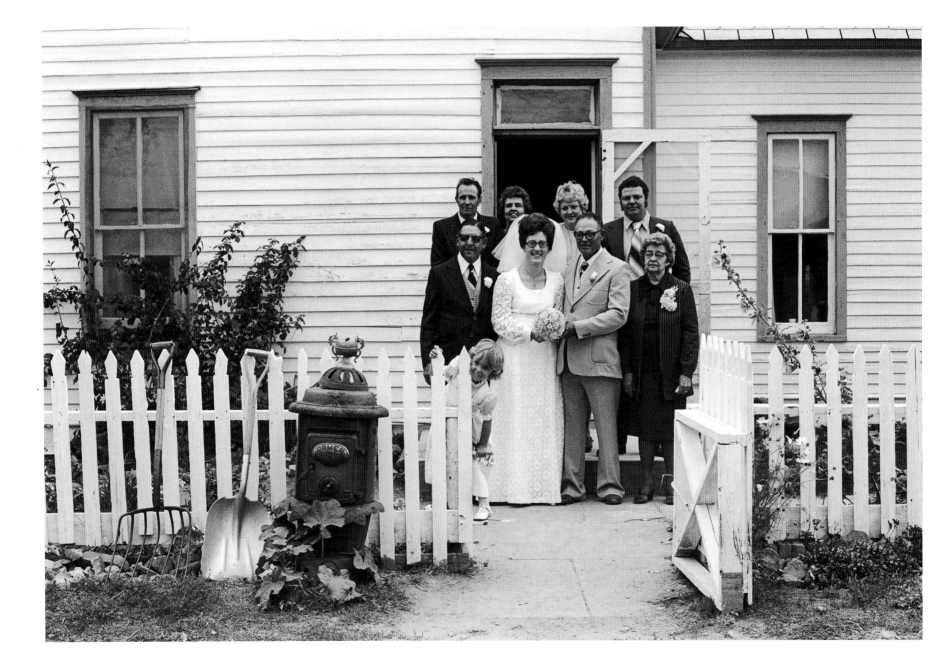

Wedding of Joanne Burns and Willard Boettger, Agate, Colorado, 1977

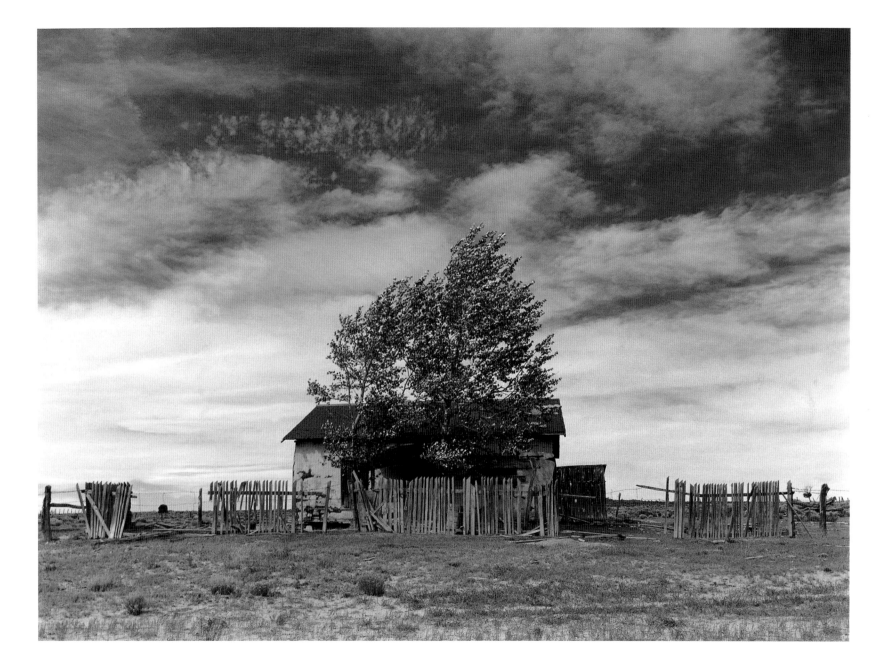

Catron County, New Mexico, 1986

THE GRASS ROOTS PEOPLE:
Pie Town

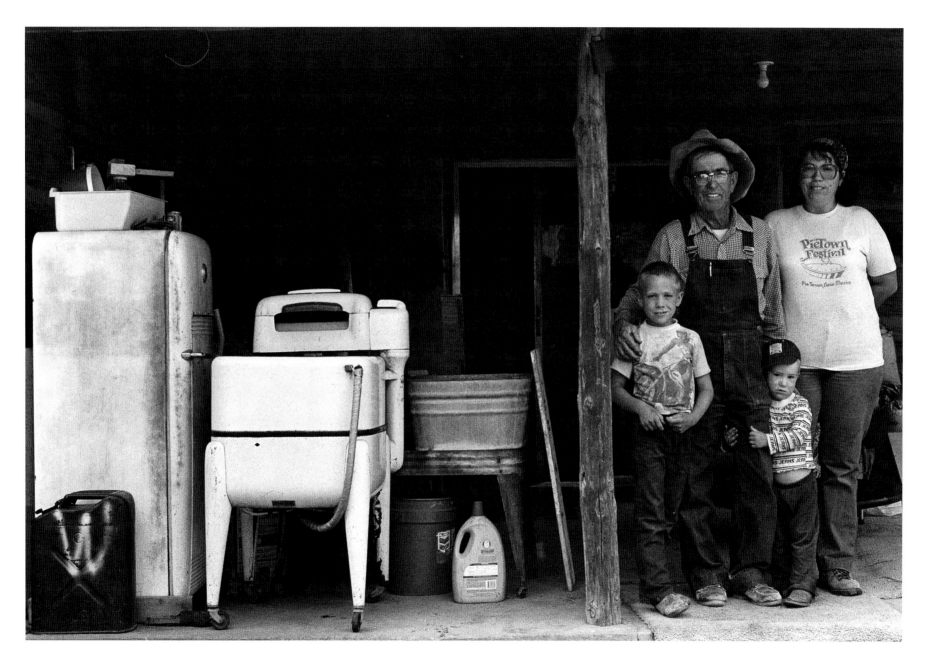

Rex and Patty Norris and sons, Collins and Thomas, 1986

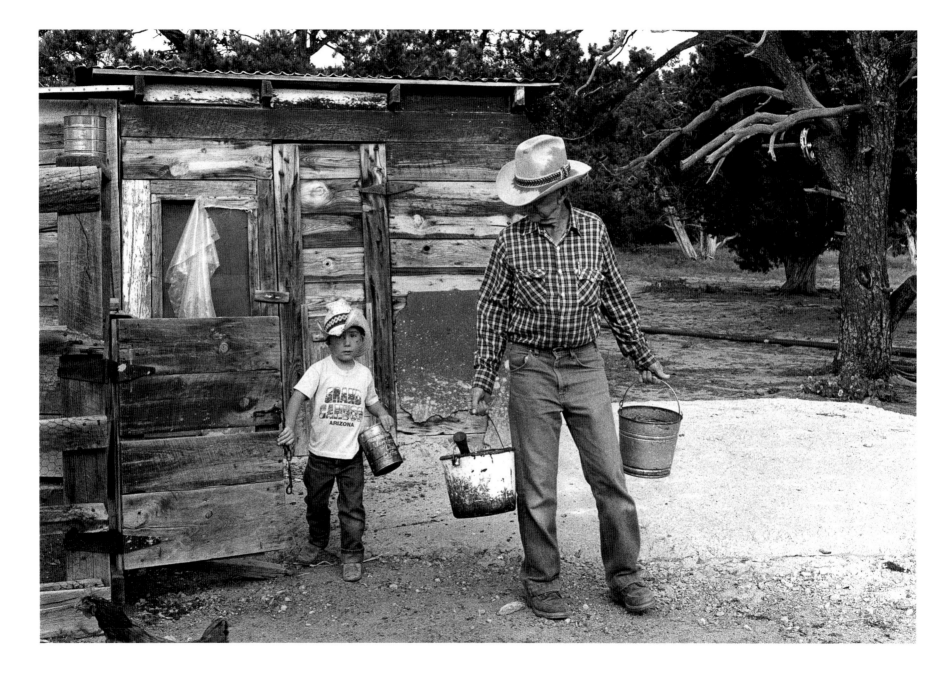

Rex Norris and son, Thomas, Pie Town, 1986

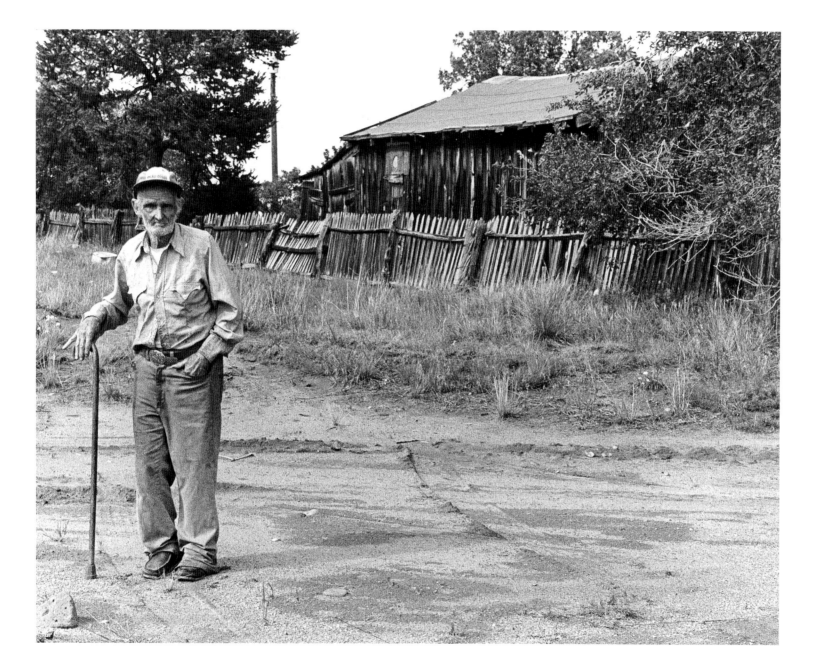

Ed Jones, pie maker of Pie Town, 1986

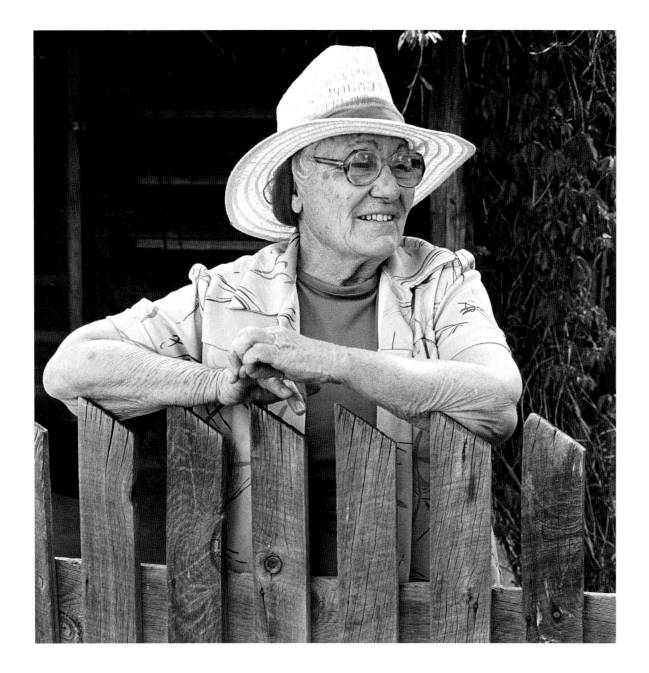

Maudie Belle McKee, Pie Town homesteader, 1986

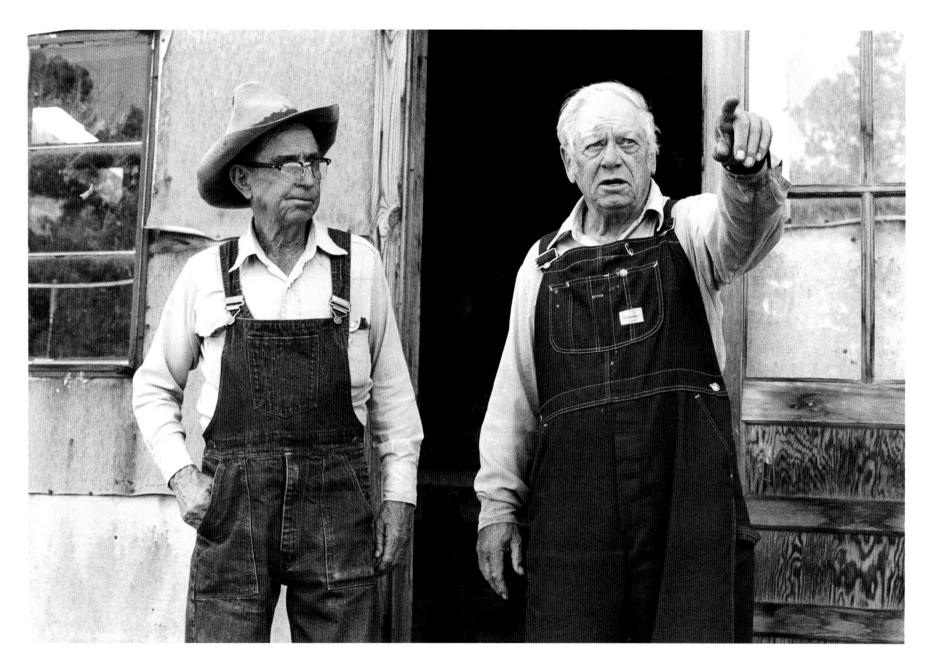

Rex Norris, left, and George Hutton, right, Pie Town homesteaders, 1986

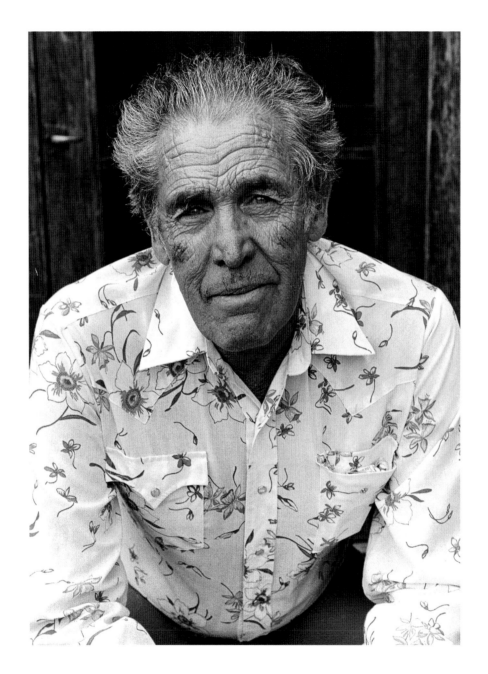

Ollie Hutton, Pie Town homesteader, 1986

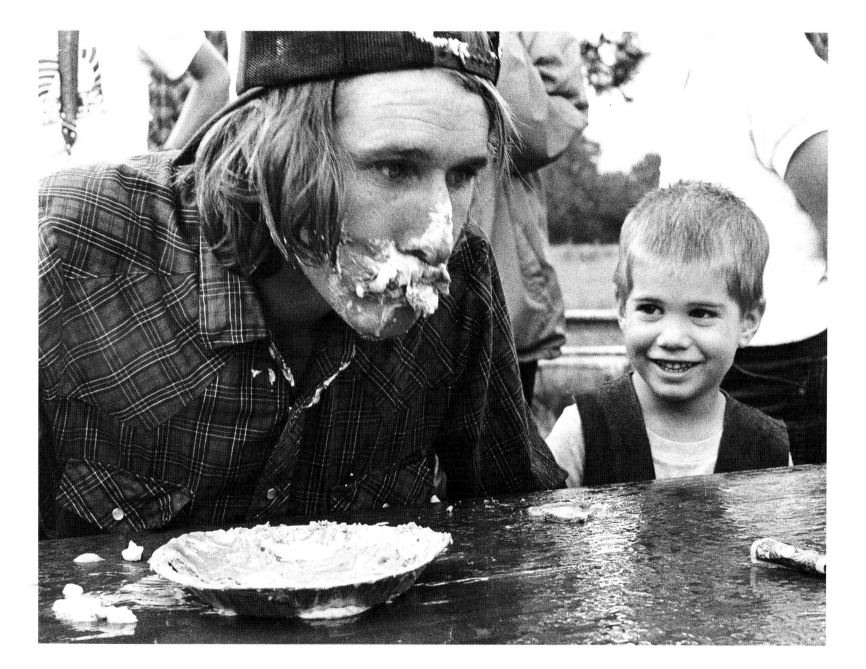

Pie Town Festival, 1985

THE UTES

I never set out to photograph the Utes. They were not part of the Grass Roots People. But one day, after a swing through Dolores and Rico, I wandered into Ignacio, where the Southern Utes lived. I knew a family there. They lived in a white government house on a street lined with identical houses. All was orderly, a far cry from when the Utes went on their last rampage a century before. I began to photograph the family and extensions of the family, the spiritual leader, the peyote chief, old people born after the government rounded up their parents from their ancestral home in the mountains and gave them land along the Pine River.

I had no time to photograph the Utes along with everything else in Colorado. But I had to make time. The culture was in transition, and no one had ever made a record of it before. I dragged myself over to Towaoc, a desolate Ute Mountain Ute reservation at the foot of Sleeping Ute Mountain. I had an introduction to a half-Southern Ute family and so I stayed, photographing not only the grinding poverty, but also happy moments like the birth of a grandson, a watermelon seed–spitting contest, a high school graduation with the Ute students in traditional dress. I was invited to the Ute Mountain Ute ranch, near Gunnison, where I rode out with the Indian cowboys at dawn, trying to juggle my camera as I bumped along. When I left, they gave me a beautiful Indian shawl. I later sent them pictures of themselves. It was that kind of thing.

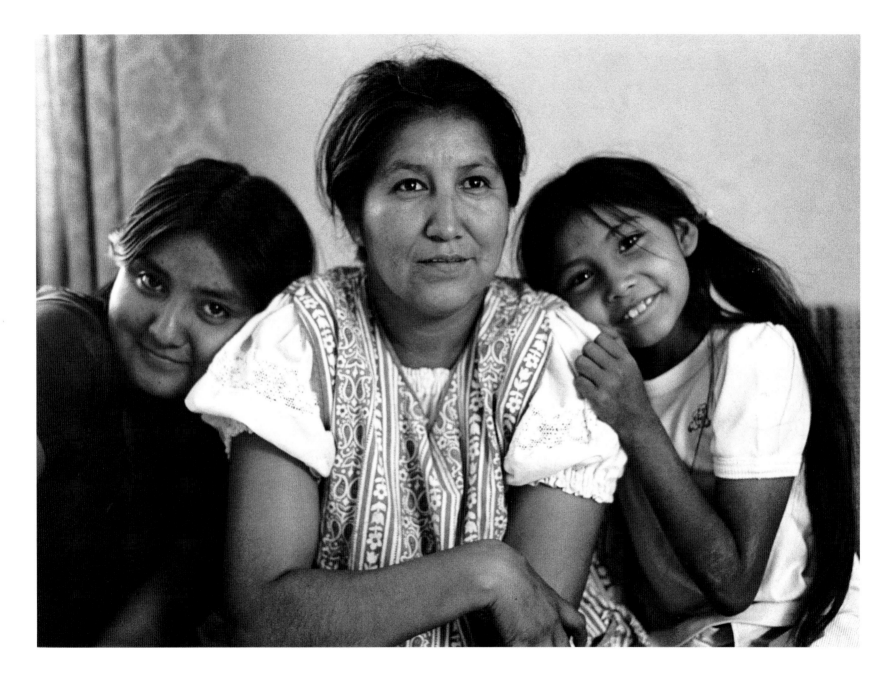

Mildred Whyte, Southern Ute, and her daughters, Melanie and MaDonna, 1977

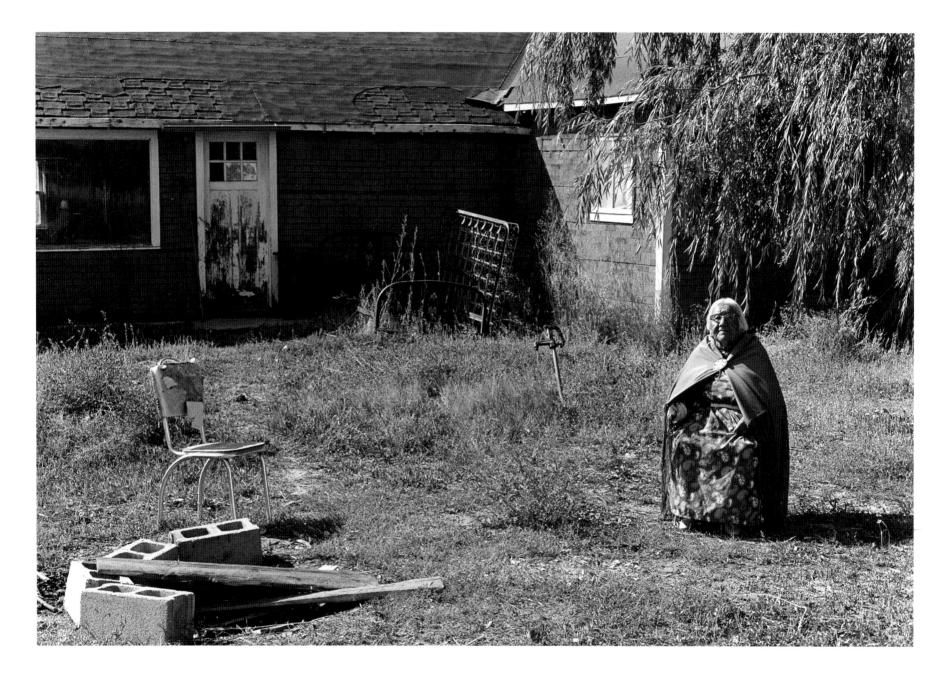

Ada Rabbit Kent, Southern Ute bead worker, Ignacio, 1978

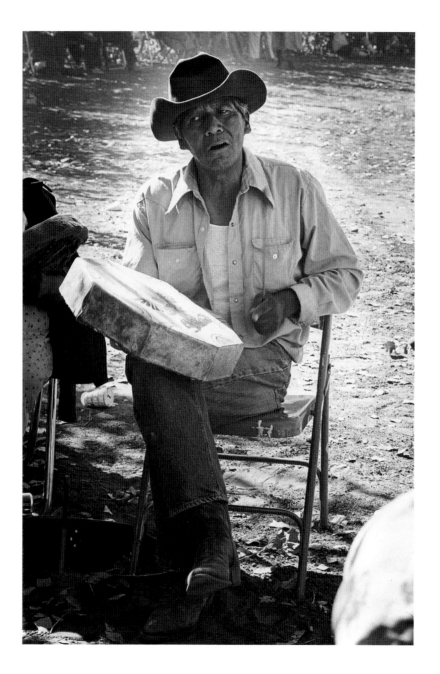

Ute Mountain Ute Bear Dance, 1979

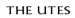

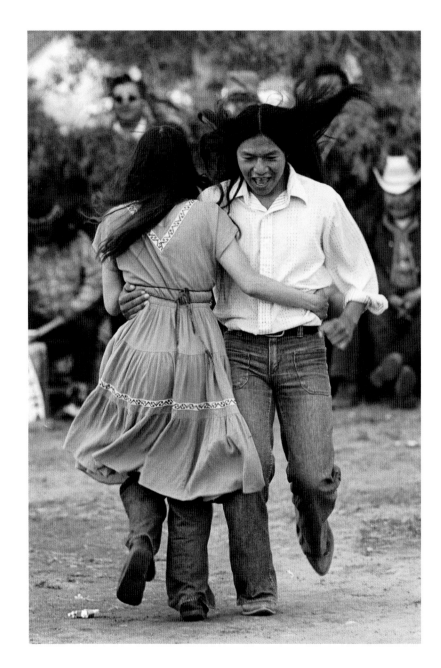

Southern Ute Bear Dance, 1976

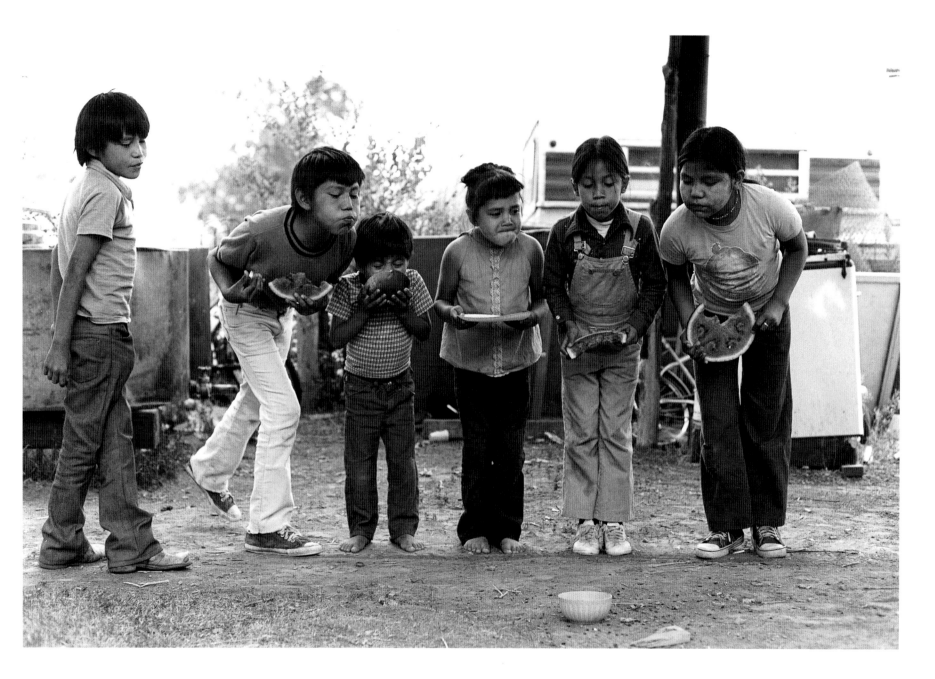

Watermelon seed–spitting contest, Towaoc, 1977

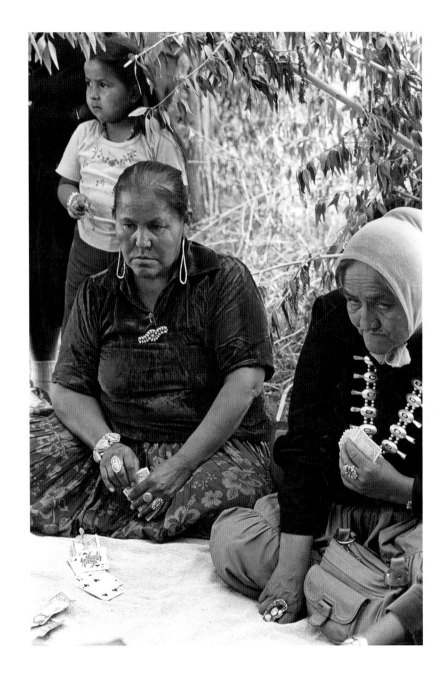

Ute Mountain Ute, Bear Dance gambling, 1979

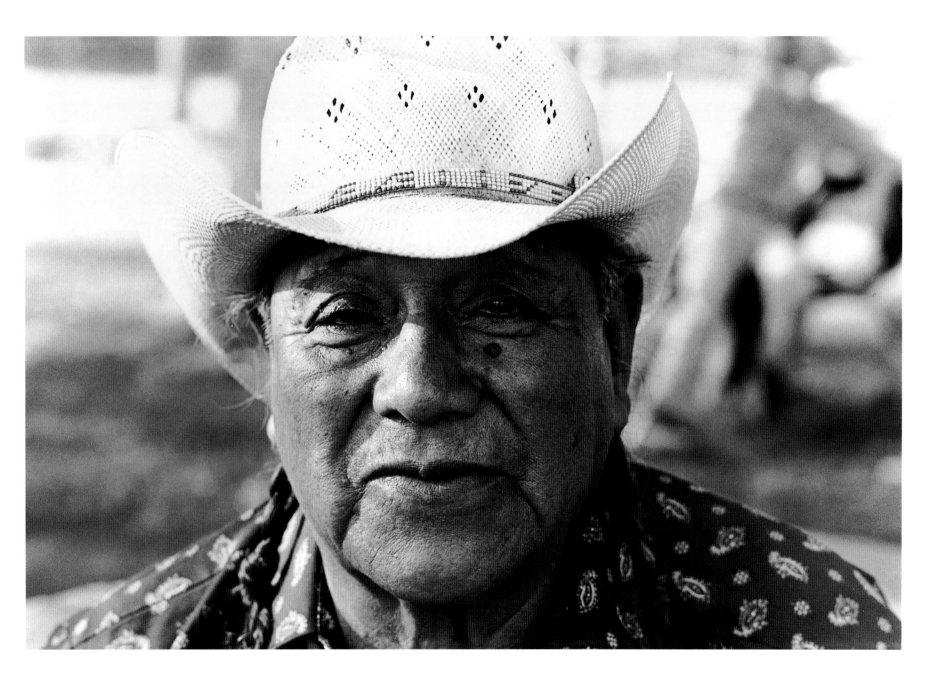

Dick McKuan, Northern Ute, 1979

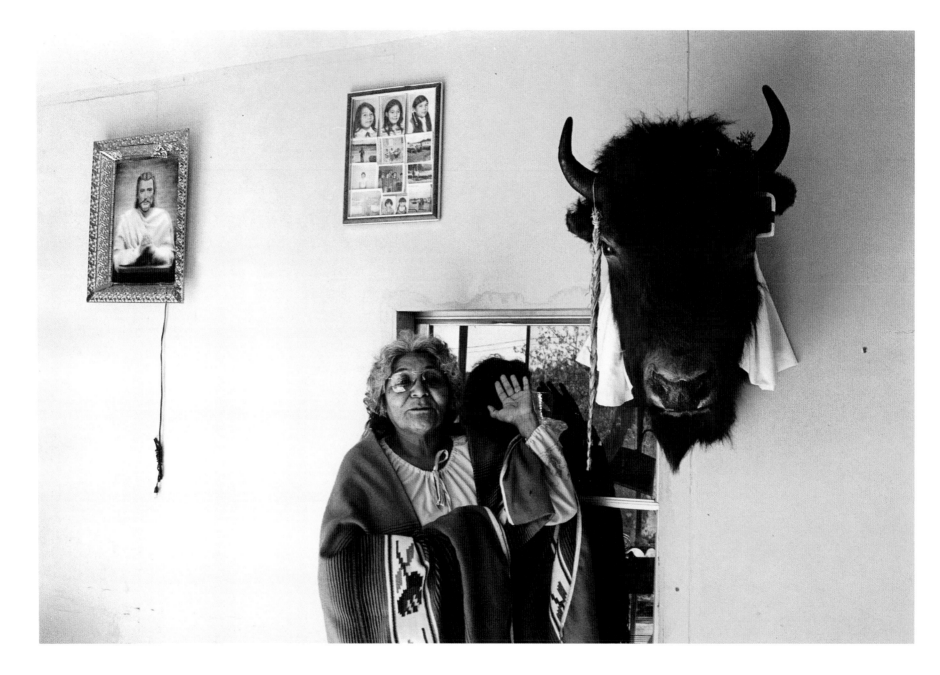

Bertha Groves, Ignacio, 1978

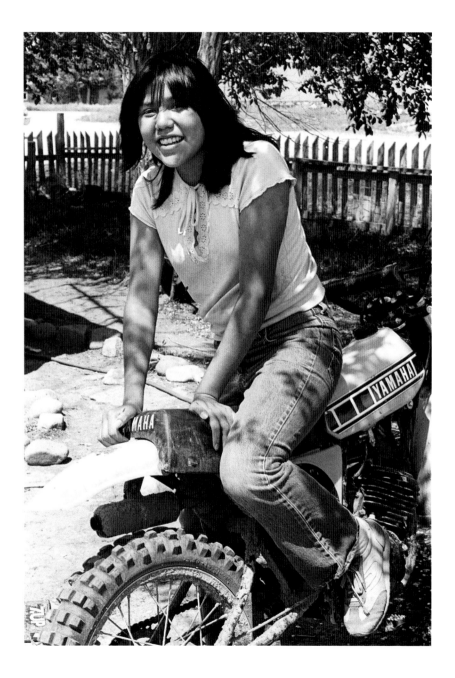

Teenager, Towaoc, 1979

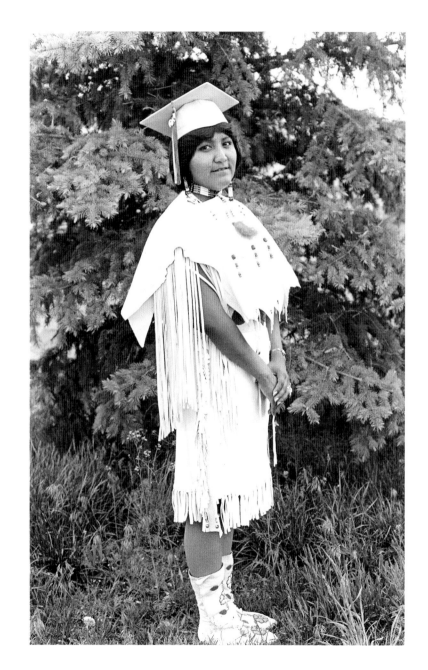

Ute Mountain Ute girl in her graduation dress, 1979

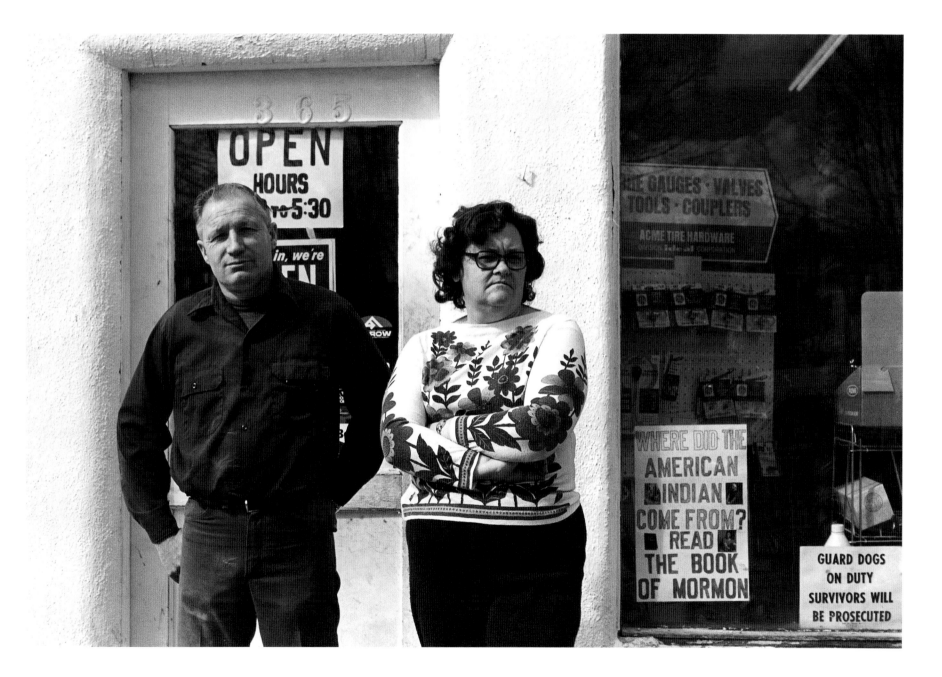

Mr. and Mrs. David Pope, Ignacio, 1977

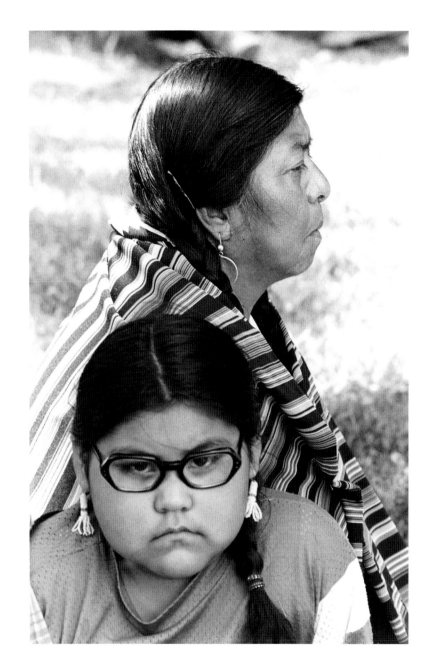

Essie Kent and her granddaughter, Ignacio, 1977

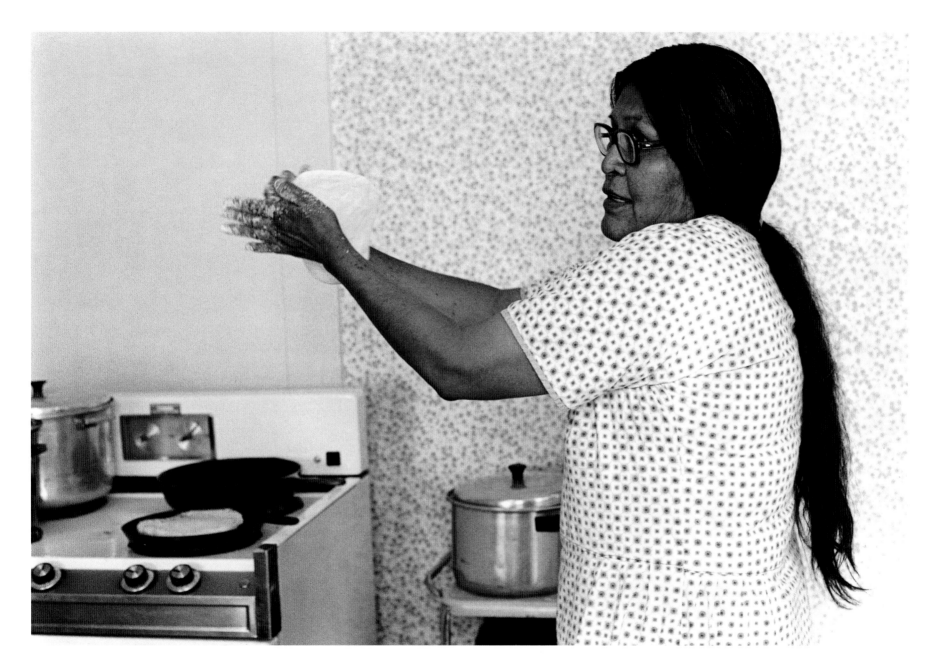

Annabelle Eagle making fry bread, Ignacio, 1976

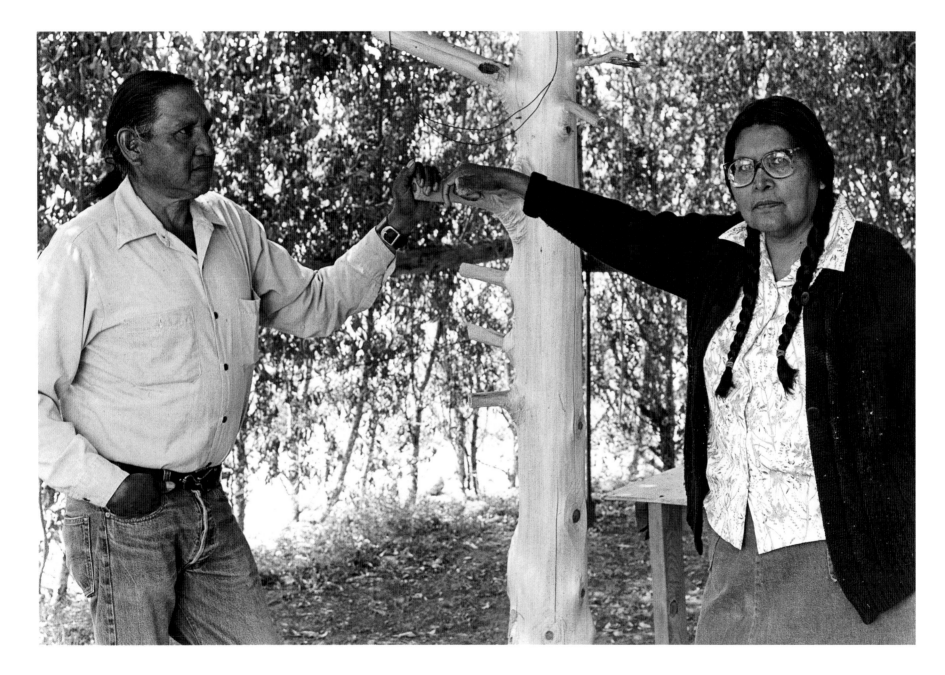

Clifford and Annabelle Eagle, Southern Utes, Ignacio, 1979

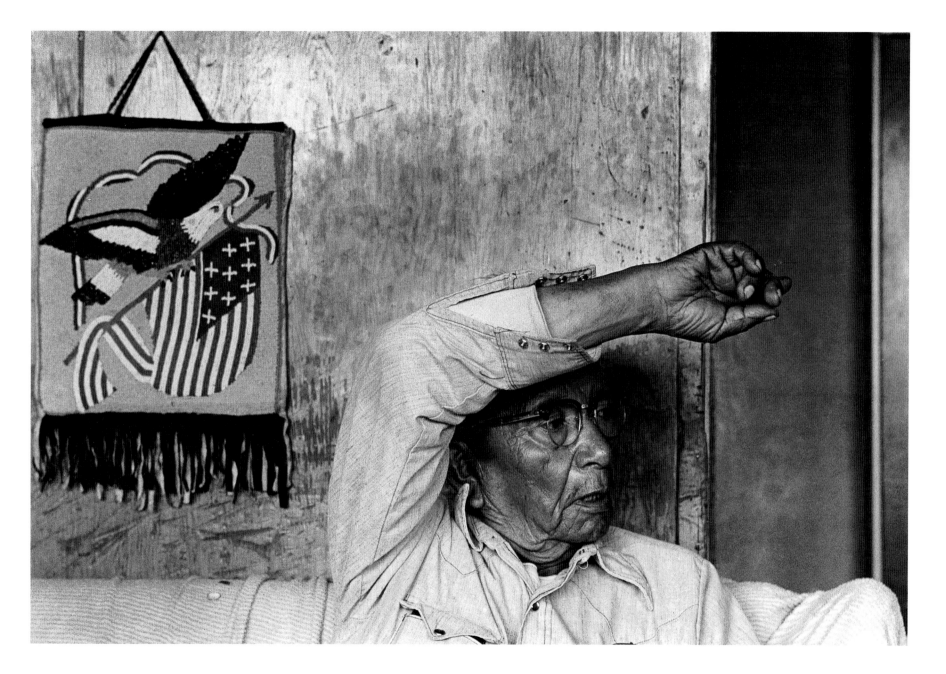

Clifford Whyte, Ute Mountain Ute chairman, 1976

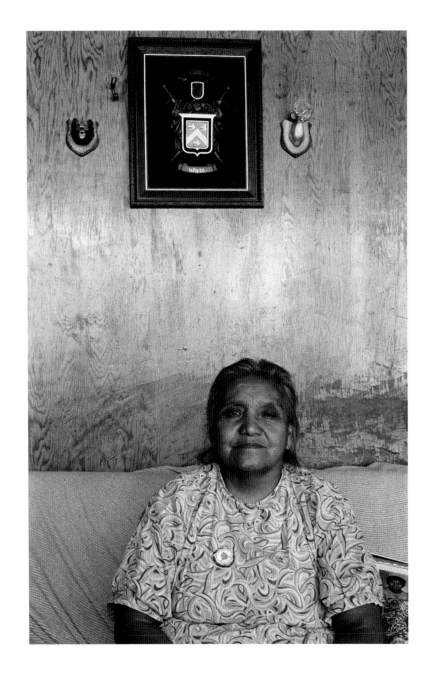

Harriet Whyte, Ute Mountain Ute, and Whyte coat of arms, Towaoc, 1976

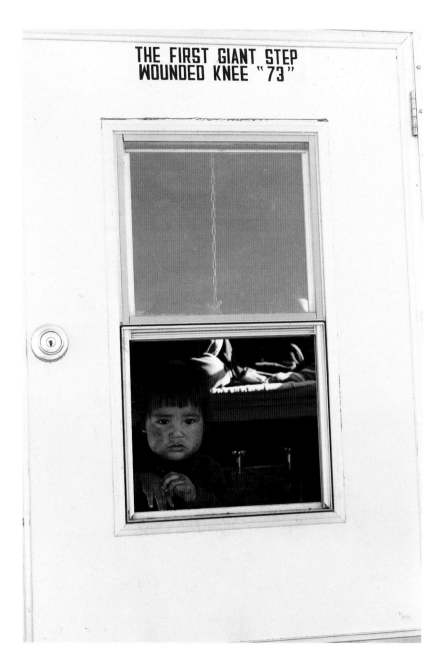

Southern Ute child in window, 1976

TAOS PUEBLO

The pueblo elder looked as if carved out of stone with his high cheekbones and hawklike nose. He walked like a panther, and he danced until he was more than seventy years old, round and round like a twenty-year-old. He was never without his plaid JC Penney cotton blanket and his handmade moccasins. He wore long braids intertwined with felt strips. He was a powerful figure at the pueblo; I never knew quite what, only that his word was law and that he could banish non-Indians he didn't like. He seemed to trust me. On the days when I sat in his tiny, airless apartment, we talked about ordinary things that upon reflection were more than ordinary. They were the key to the life he led.

The old man died before I started to photograph Taos Pueblo. Yet from the time I took my first pictures, I thought of him. What would he want me to do? Traditions, he seemed to say from somewhere. I concentrated on old men like him, on old women he had known all his life. I looked at the plaza and the river and the ancient trash heaps. I imagined American soldiers coming to shell the church in 1848. Woman and children took refuge inside the thick adobe walls, believing themselves safe in the house of God. I went to the cemetery and looked at the ruins of the church and the simple wooden crosses. Heartbreak and courage were there.

One morning I climbed the ladder to the rooftop and sat with some friends looking down at the plaza. There were drying racks and bread ovens. Pickup trucks. Indians hurrying around in contemporary dress. I asked myself why I expected them to stay in the nineteenth century. The perpetuation of the myth of the North American Indian created by Edward S. Curtis had to stop with me. I climbed down the ladder and photographed a girl in a miniskirt and sneakers.

After that, I took pictures of a boy in a Grateful Dead T-shirt. They looked Indian to me.

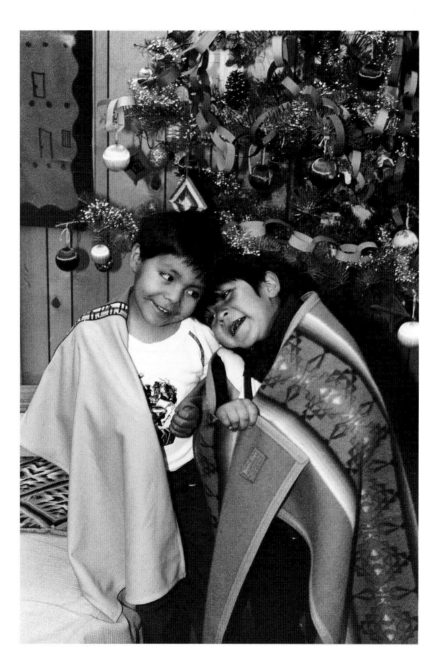

Two boys at Day School Christmas party, 1988

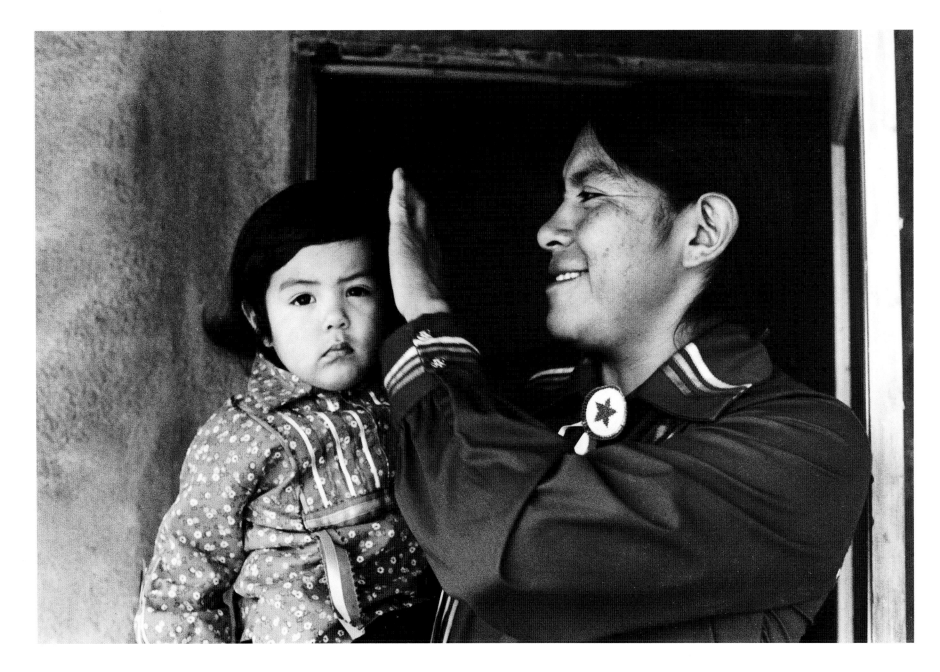

Albert Martinez Jr. and his son, 1984

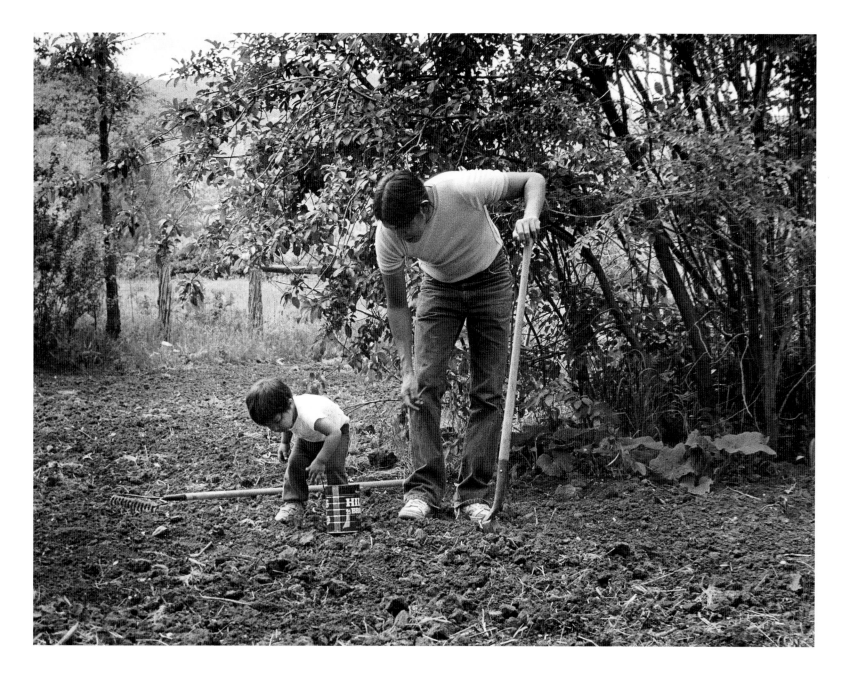

Albert Martinez teaching his son to plant corn, 1986

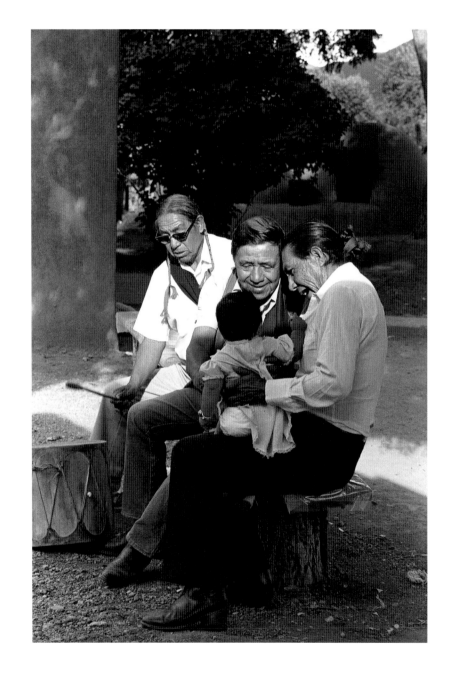

Three men and a baby, 1986

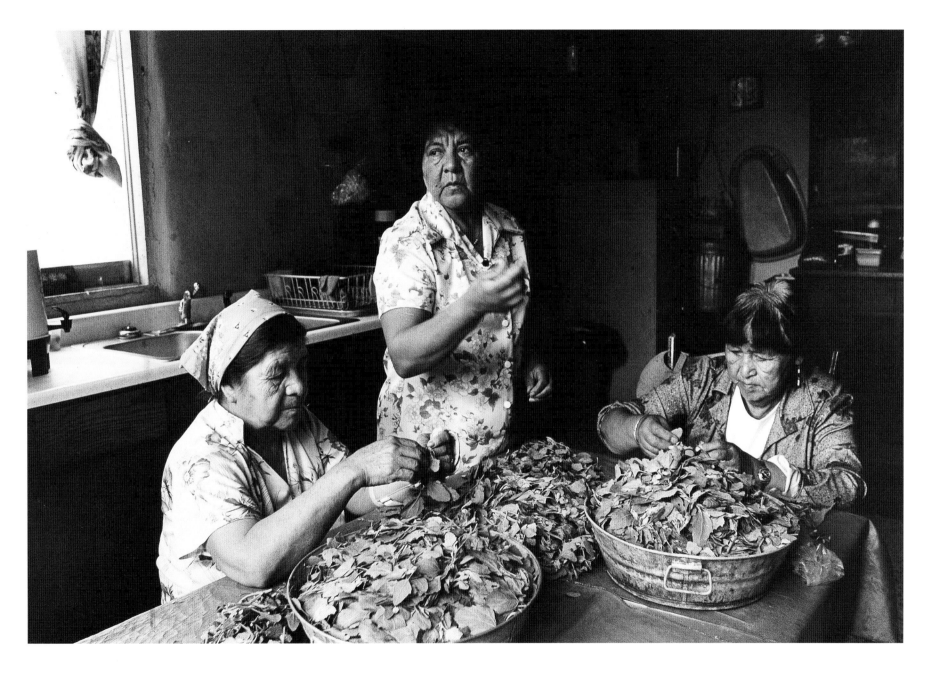

Cleaning wild spinach, 1986

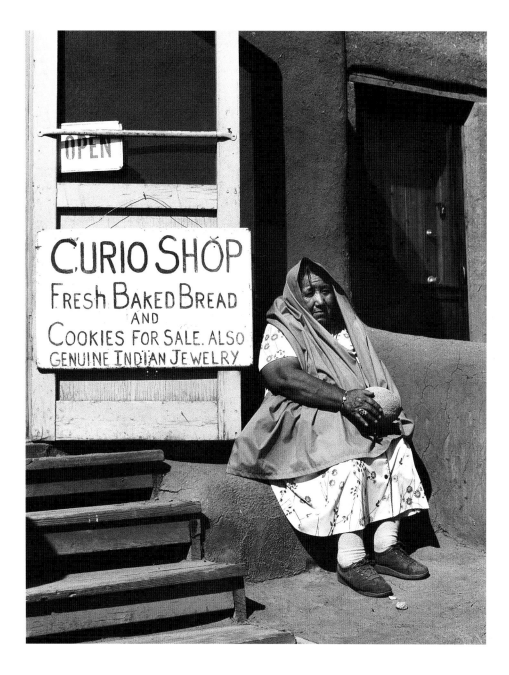

Mrs. Romero, who has had a shop on the plaza since 1936, photo taken in 1987

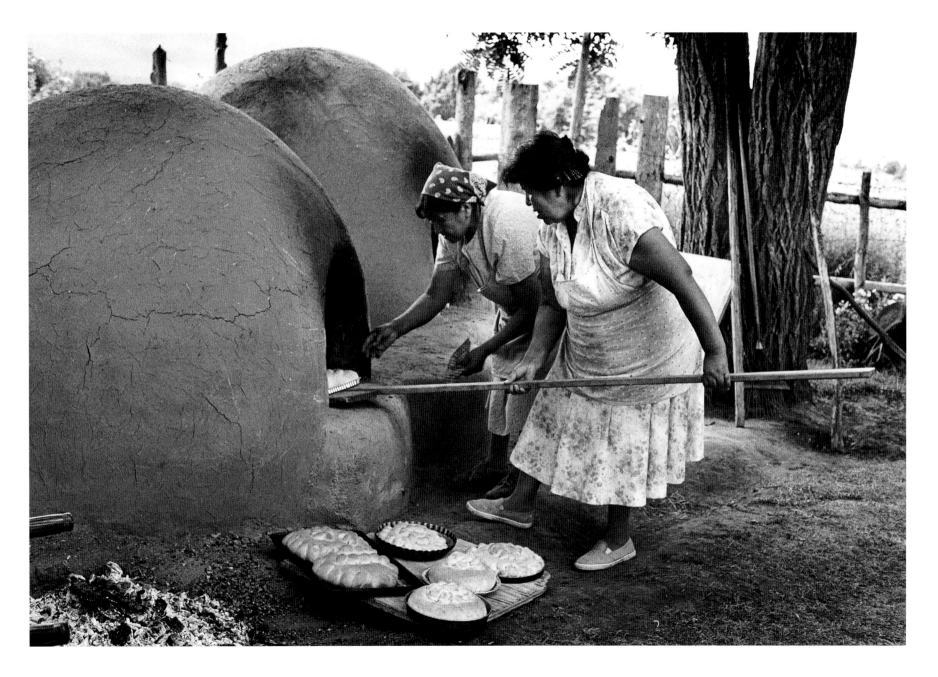

Baking bread for feast day, 1985

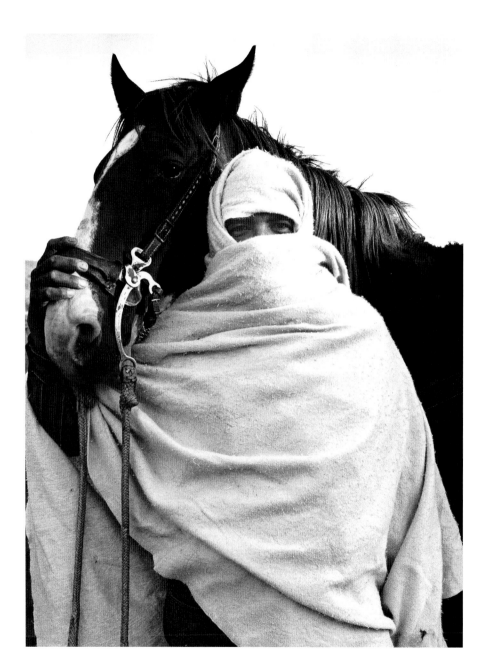

Cesario Gomez, Taos Pueblo Horse Ranch, 1989

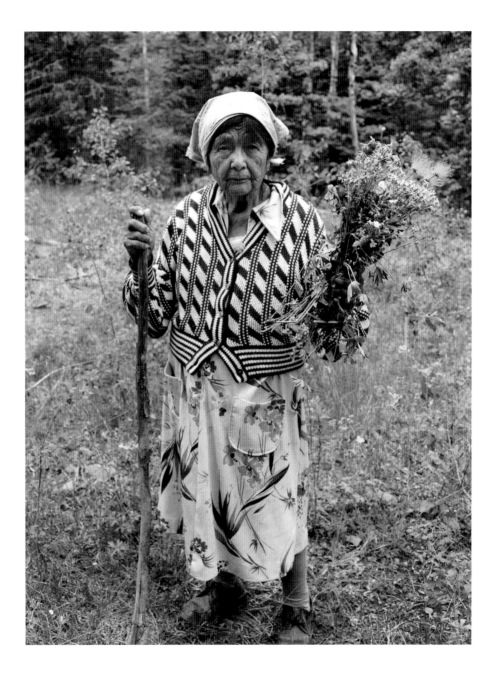

Maria Mondragon, 1986

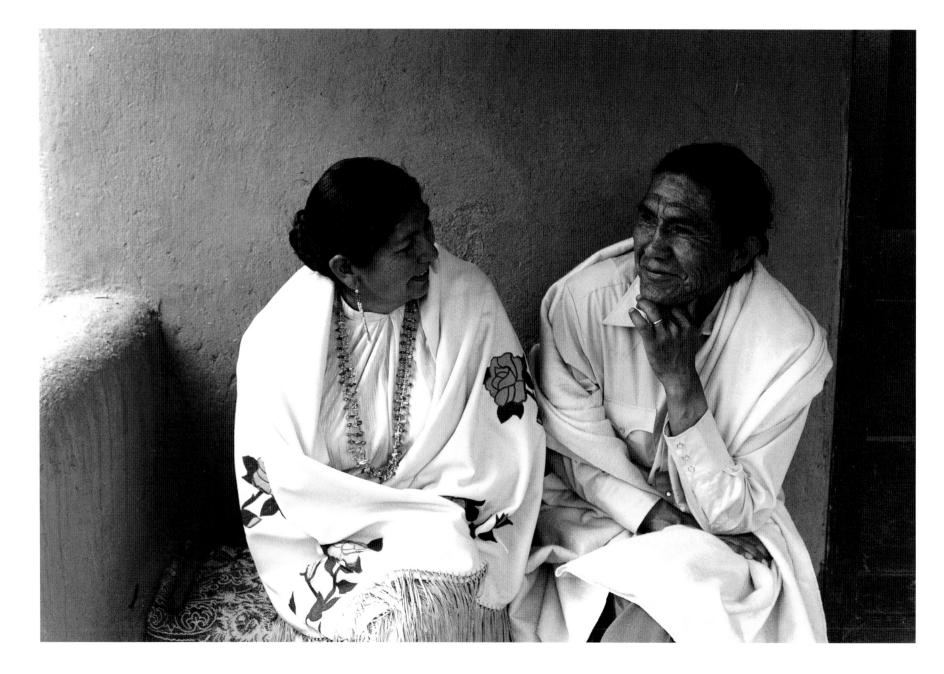

Frank and Josephine Marcus, 1983

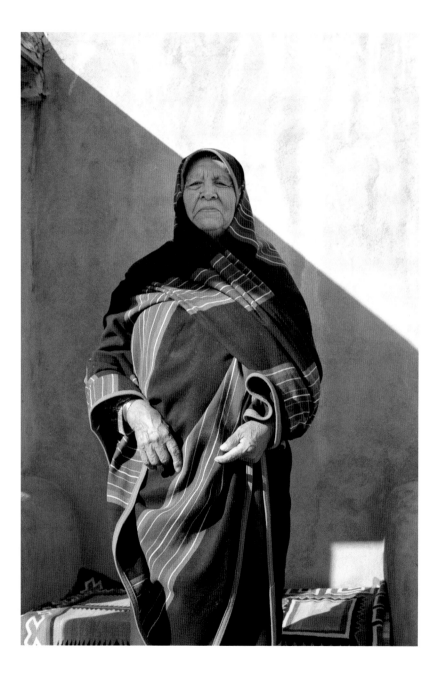

Eliseo Concha, Taos Pueblo elder, 1985

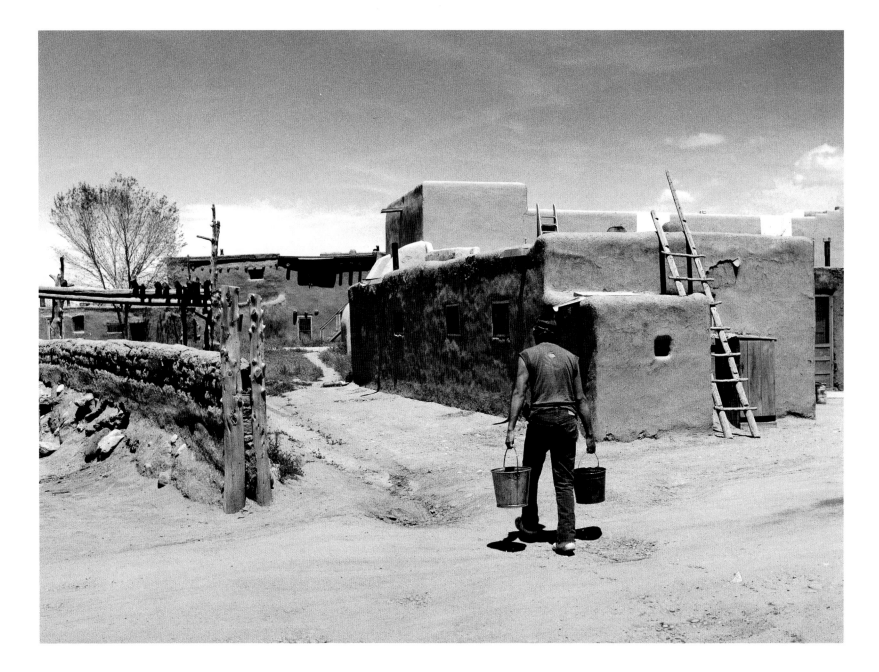

Hauling water from Taos Creek, 1985

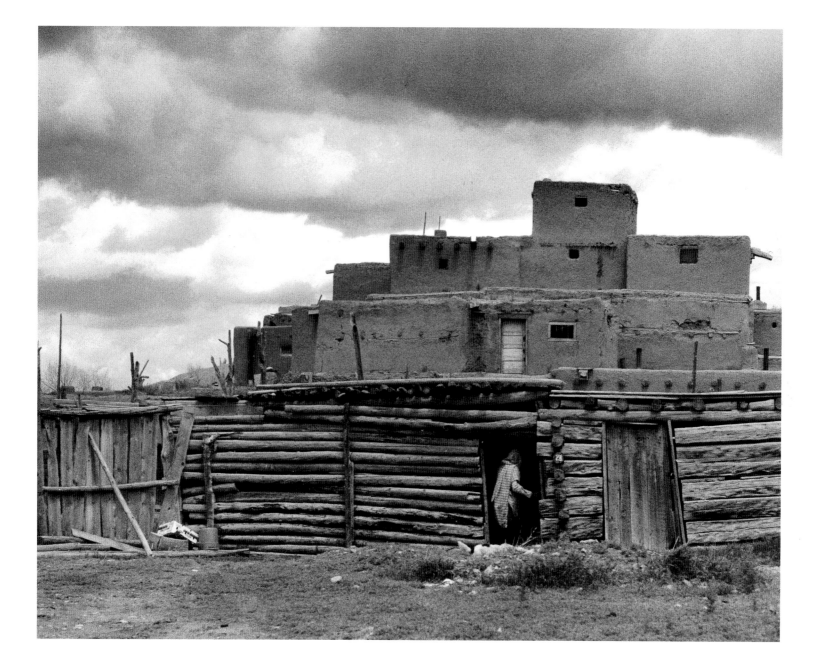

Taos Pueblo, south side, 1985

Drum maker Red Shirt Reyna cutting logs with James Montoya, 1985

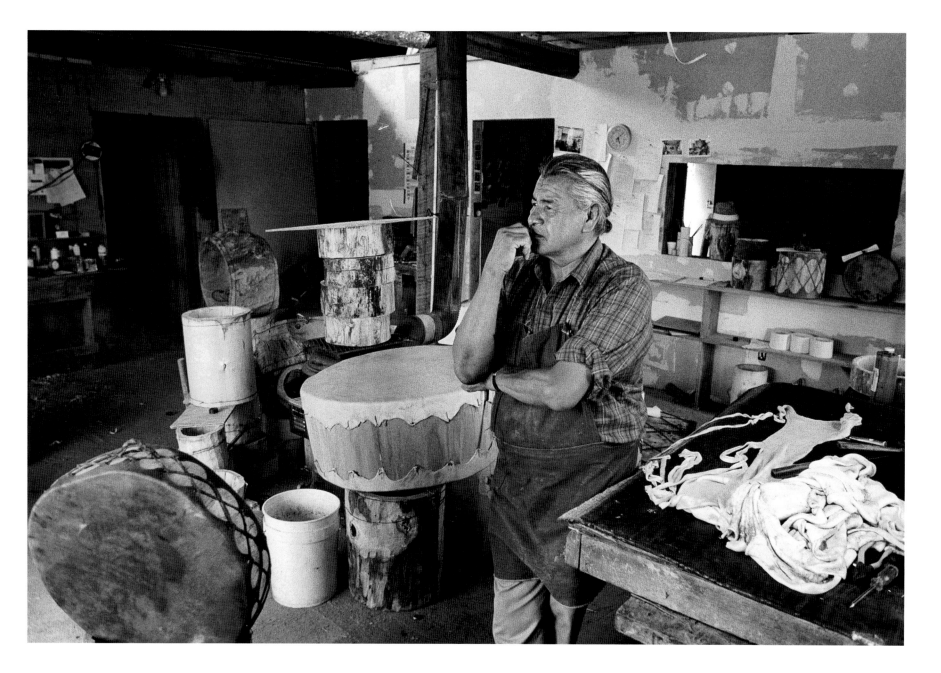

Red Shirt Reyna, drum maker, 1988

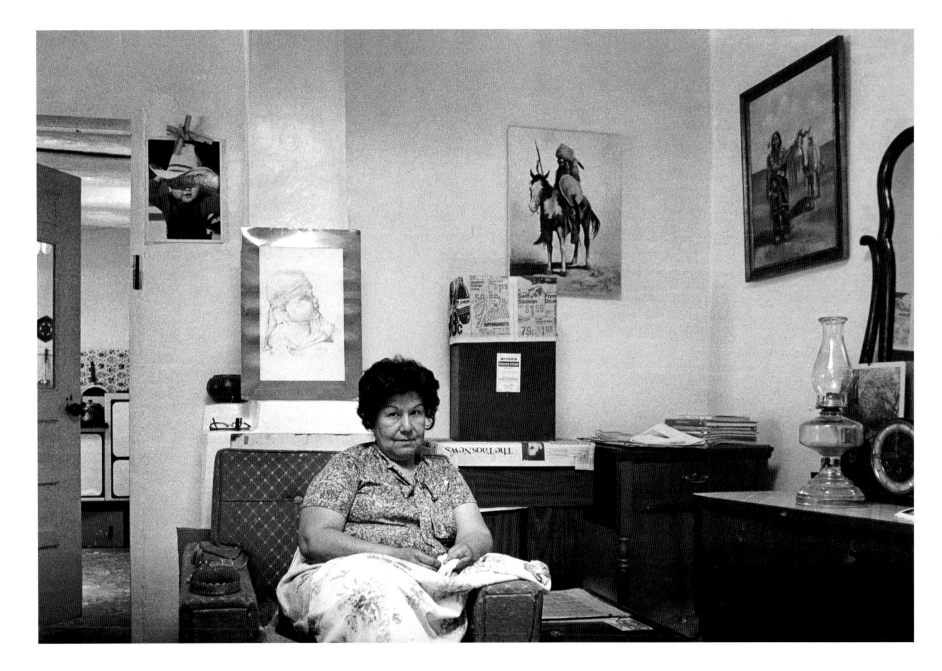

Taos Pueblo home, 1985

Pueblo entrance, 1985

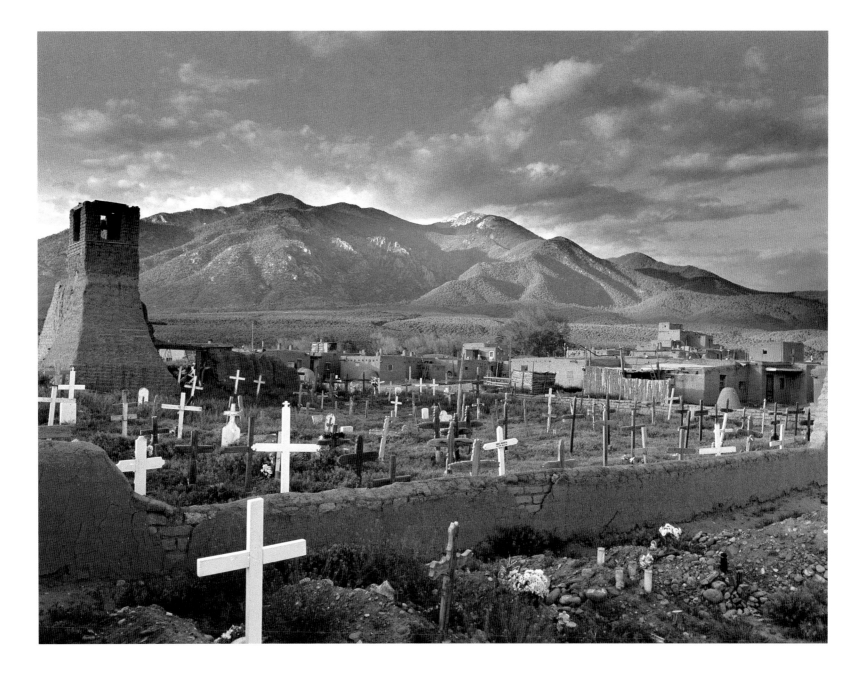

Graveyard and old church, Taos Pueblo, 1985

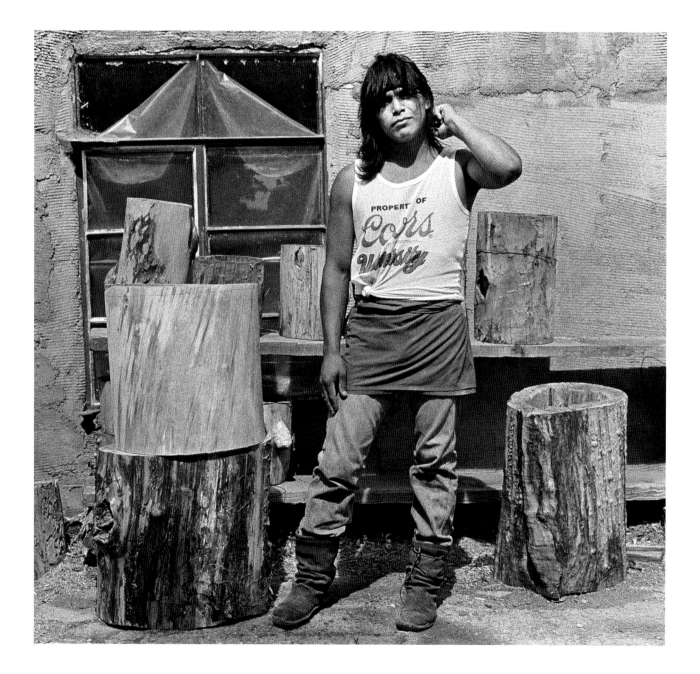

James Montoya, apprentice to drum maker, 1985

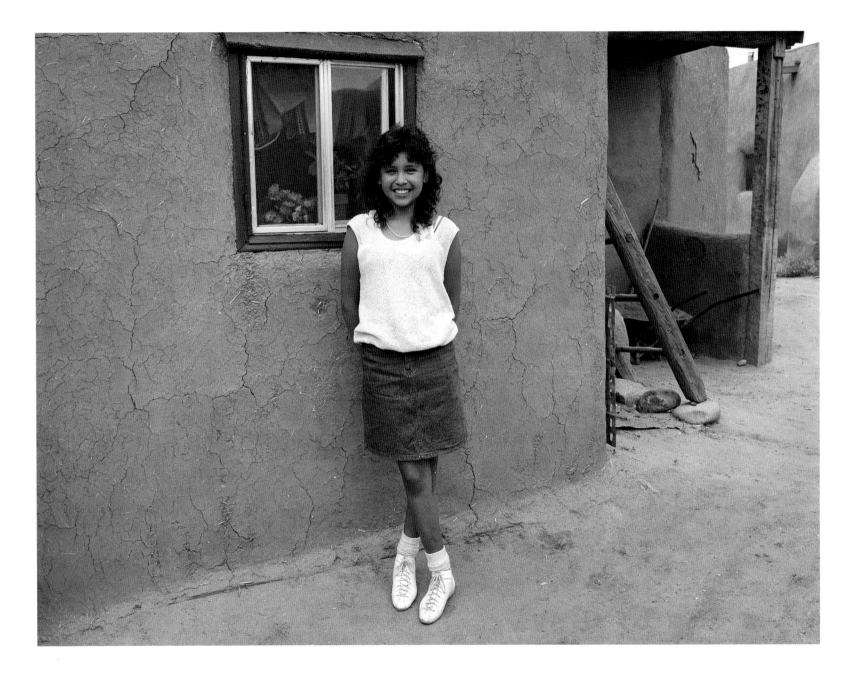

Pueblo girl, 1986

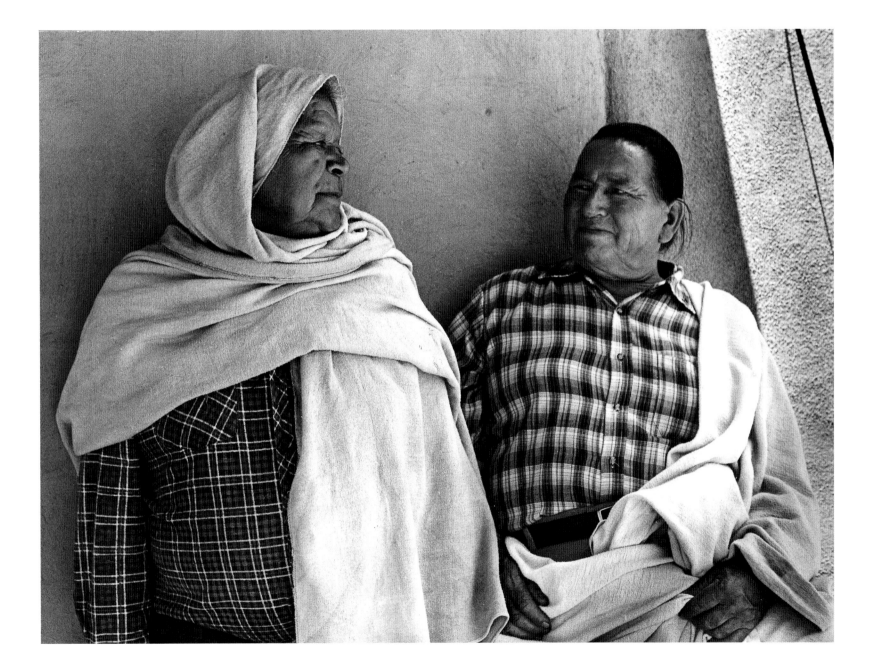

Old friends, 1985

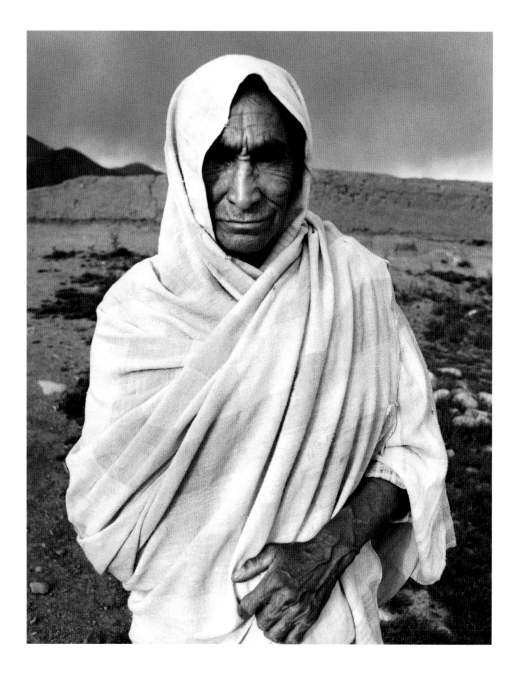

Elder, Taos Pueblo, 1986

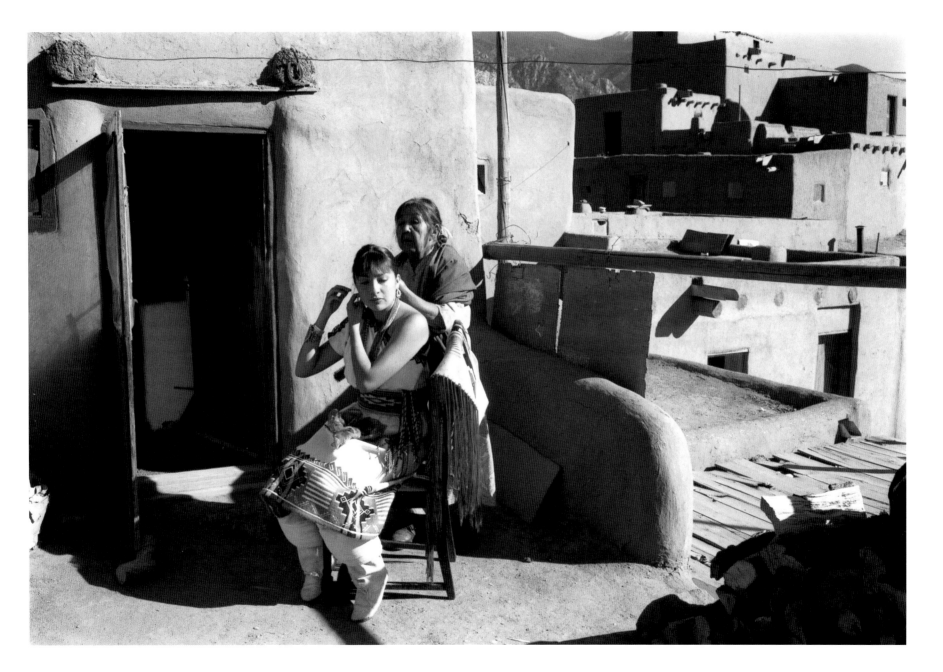

Manuelita Marcus fixing her granddaughter's hair, 1986

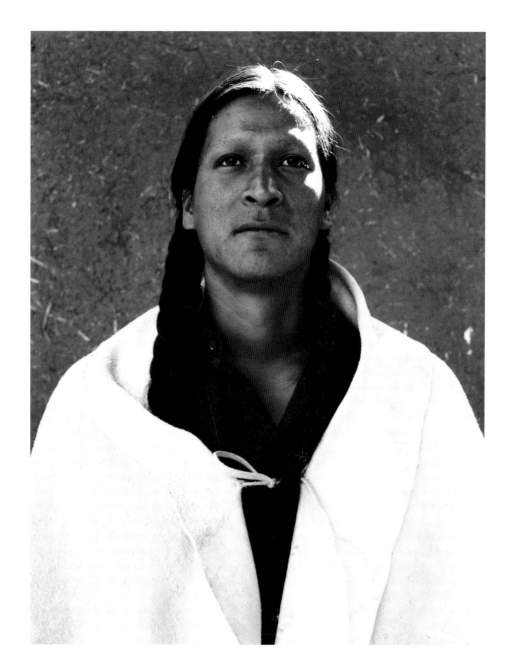

Matthew Montoya, 1987

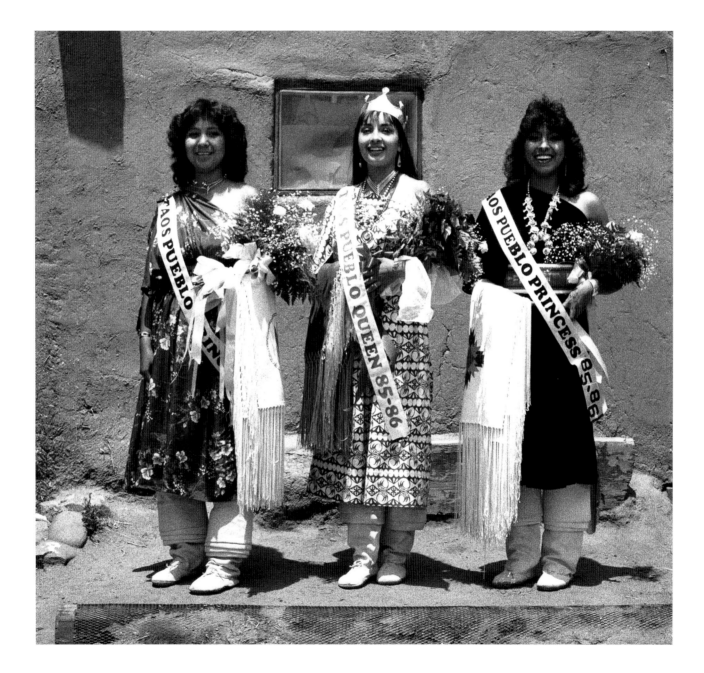

Taos Pueblo beauty queens, 1986

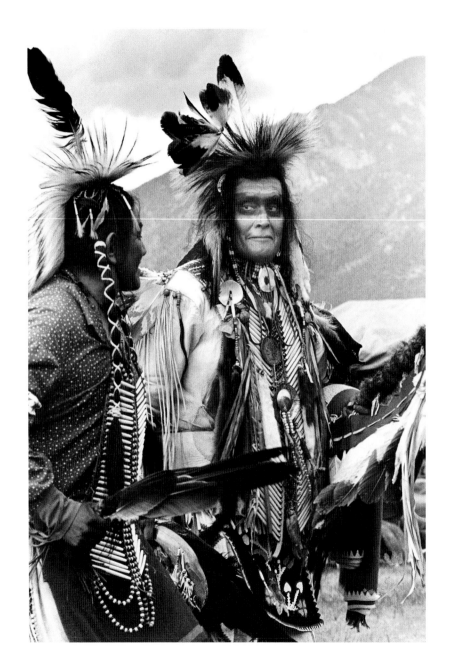

Taos Powwow, 1985

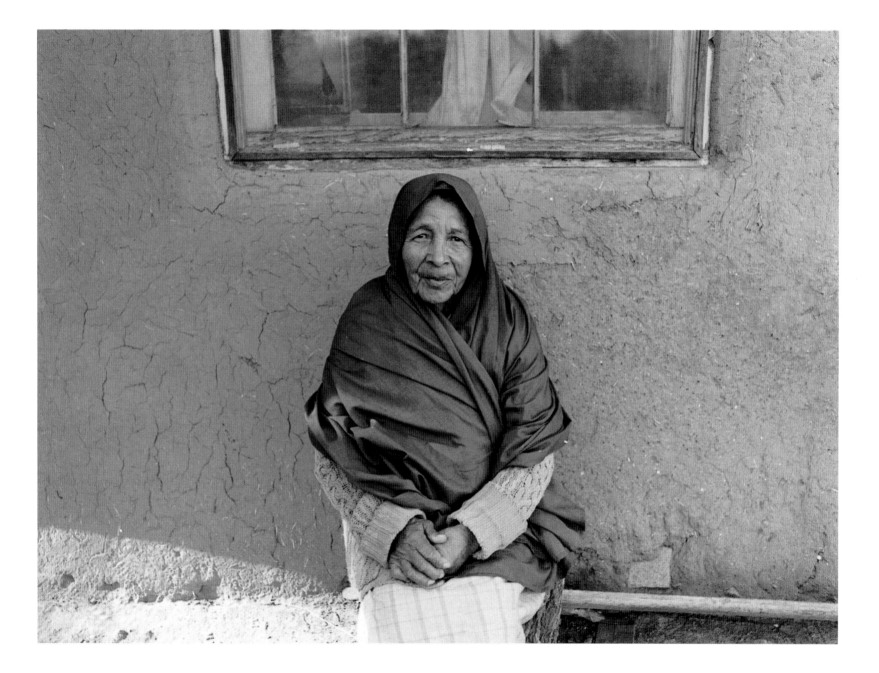

Crusita Romero, 1986

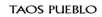

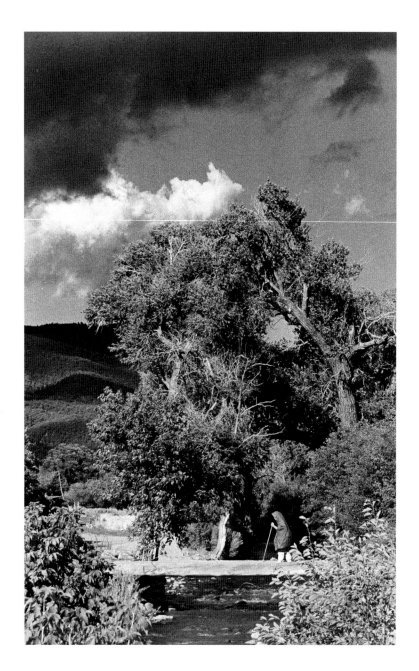

Old lady crossing bridge, 1985

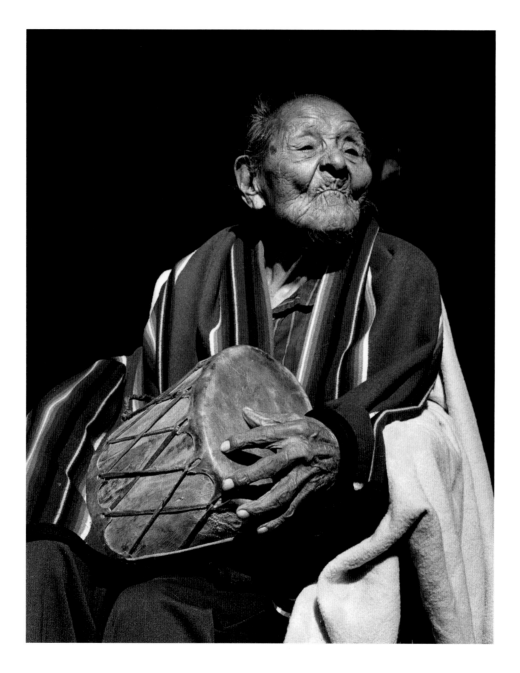

Francisco Martinez, 103 years old, 1986

BOOKS BY NANCY WOOD

Poetry

Dancing Moons. New York: Doubleday, 1995.

Hollering Sun. New York: Simon and Schuster, 1972.

Many Winters. New York: Doubleday, 1974. Reprint, 1992.

Sacred Fire. New York: Doubleday, 1998.

Shaman's Circle. New York: Doubleday, 1996.

Spirit Walker. New York: Doubleday, 1993.

War Cry on a Prayer Feather. New York: Doubleday, 1979.

Collections

The Serpent's Tongue. New York: Dutton, 1997.

Fiction

The King of Liberty Bend. New York: Harper and Row, 1976.

The Last Five Dollar Baby. New York: Harper and Row, 1972.

The Man Who Gave Thunder to the Earth. Doubleday, 1976.

Thunderwoman. New York: Dutton, 1999.

Non-Fiction

Clearcut: The Deforestation of America. San Francisco: Sierra Club, 1972.

Colorado: Big Mountain Country. New York: Doubleday, 1969.

When Buffalo Free the Mountains: A Ute Indian Story. New York: Doubleday, 1980.

For Children

The Girl Who Loved Coyotes: Stories of the Southwest. HarperCollins, 1995.

How the Tiny People Grew Tall: An Original Creation Tale. Cambridge, MA: Candlewick, 2005.

Little Wrangler. New York: Doubleday, 1966.

Mr. and Mrs. God in the Creation Kitchen. Cambridge, MA: Candlewick, 2006.

Old Coyote. Cambridge, MA: Candlewick, 2004.

Photography

The Grass Roots People: An American Requiem. New York: Harper and Row, 1978.

Heartland New Mexico: Photographs from the Farm Security Administration, 1935–1943. Albuquerque: University of New Mexico Press, 1989.

In This Proud Land: America, 1935–1943, as Seen in the FSA Photographs. With Roy Stryker. New York Graphic Society, 1974.

Taos Pueblo. New York: Knopf, 1989.